INTRODUCTION

The human face and figure have always been central to artistic practice. A portrait should not only identify specific individuals by their physical features but also express their personalities, thoughts and emotions via their expressions. When we think of somebody, the first thing we call to mind will nearly always be the features of that person's face in one of its characteristic expressions. The impulse to draw this face may come from a desire we have to capture the traits that render the face unique and allow the person's character to show through. A person's physical appearance and their personality are intimately linked and what distinguishes a portrait, in the most widely used sense of the word, from a figure study or generalised depiction of a face is this descriptive treatment given to a person's idiosyncratic characteristics.

An extremely useful way to train and improve your observational abilities in this respect is to make drawings and sketches. The best method for carrying out a portrait or study of somebody's head (and such studies will frequently turn out as 'accidental portraits') is to examine the anatomical form and structure of the head, analysing its overall proportions as well as those of each facial feature and relating these to each other. The drawing precision and exact positioning of the facial features are two essential elements for guaranteeing what many consider the fundamental attribute of any portrait – its resemblance to the subject. Additionally, the artist's empathetic perception of the mood and character of the model will help with the overall portrait.

In this book, I have attempted to direct the attention of fellow artists to the graphical and aesthetic opportunities that are present in every face. The faces of complete strangers, of people you know nothing about and who you encounter by chance, can attract interest through their characteristic features alone. What is usually meant by the term 'a characteristic face' is a face in which the overall shape, individual features or habitual expression exhibit a marked characteristic with particular prominence: all of these are elements which will spur the artist's investigative curiosity and aesthetic sense.

In brief, for artists who develop the habit of using their pencil to fill their sketchbooks with studies such as these, simply noticing passers-by in any public place will guarantee a plentiful supply of attractive and interesting faces.

To my mother, to my father

GETTING STARTED

Depth of thought is redeemed by lightness of touch.

USING PLASTER CASTS

When setting out to study the human head – especially during the early stages of learning – it can be very helpful to use a plaster cast that faithfully reproduces a high-quality, realistic piece of sculpture. In traditional art academies, plaster casts of works by great artists such as Donatello, Michelangelo and Houdon or other examples from past artistic civilisations, such as classical Greek and Roman art, are made available to students. This may seem to be an outmoded and rather boring way of practicing, but if it is done with thought and artistic freedom, the technique can still prove very useful, even today. This is because drawing from plaster casts allows the student to work slowly, without the urgency imposed by using a moving model. In this way students can develop a keen ability in observing forms by exploring proportional relationships and volumes and acquire the technical mastery to express these observations effectively through variation of tone.

USING PHOTOGRAPHS

Photography is a very useful and sometimes indispensible resource in situations in which drawing is not possible or when the model is surprised in a crowded place or caught performing a rapid, unrehearsed and unrepeatable movement. In such circumstances, photography (an art form in itself) offers many practical advantages to the artist: it makes an instant record of fleeting expressions and minute facial details, its form and the play of light, which would

escape an inattentive glance and be impossible to jot down in a rapid sketch. Photographs allow the portraitist to carry on with his work in the studio, at leisure, when the model is not there. It is by no means a matter of simply copying the photographic image, but to put the objectively recorded information to good use in attaining an authentic and living likeness, combining data gathered from direct observation of the model (as and when possible) and from photographs depicting the model. The artist's task is to create an atmosphere within an image that, in summarising observed reality, goes beyond it. In short, photography is not a substitute for direct observation or for making sketches from life: it should be seen as a tool in the hands of the graphic artist and utilised as such.

When you use a camera to take photographs for reference or for documentation, it is advisable to make allowances for the optical limitations of this mechanical instrument, especially when you are using photographs taken by other people. Human vision is binocular, but cameras 'see' the world through a single lens and so variations in focal length can lead to distortions in a face's proportions and the perspective in which it is seen. Such distortions may be minimal, but they are there nonetheless and can be compensated for either by retaking the photograph from the correct distance or by using appropriate telephoto lenses. Photographic film and digital images are less sensitive than the human eye, especially in the case of colour pictures, and they nearly always produce images in which either the shadows are too dark or the light areas too bright. For this reason, when taking photographs for a portrait, direct sunlight and poorly lit interiors are both best avoided; it is better to opt for diffuse daylight conditions.

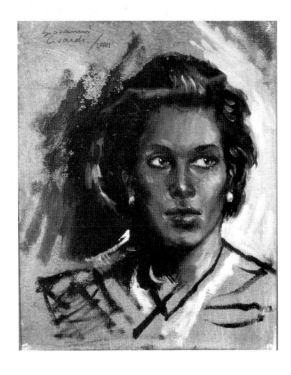

Portrait study (1968), oil on canvas, 21 × 26cm (8¼ × 10¼in)

STOCKPORT
METROPOLITAN BOROUGH COUNCIL

Libraries,
Advice and
Information

08/12 B2A

MAR DS

''/15.

19/10.

V

0 6 FEB 2018
1 6 MAR 2018
1 6 MAR 2018

0 4 APR 2018

25 APR 2023

Please return/renew this item
by the last date shown.
Books may also be renewed by
phone or the Internet.

Tel: 0161 217 6009
www.stockport.gov.uk/libraries

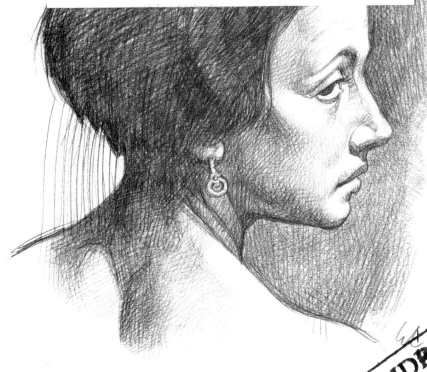

STOCKPORT LIBRARIES

WITHDRAWN FROM CIRCULATION

C2000 00187 0472

May 2010

Giovanni Guglielmo Civardi was born in Milan on
22 July 1947. Following a period working as an illustrator,
portraitist and sculptor, he spent many years studying human
anatomy for artists. He also teaches courses on drawing the
human figure.

'Perhaps joy is a fleeting expression of pain'

'Eternity may condense itself into an instant'

First published in Great Britain 2012 by Search Press Limited,
Wellwood, North Farm Road, Tunbridge Wells, Kent TN2 3DR

Originally published in Italy by Il Castello Collane Tecniche,
Milano

Copyright © Il Castello S.r.l., via Milano 73/75,
20010 Cornaredo (MI), 2011 *La testa e il volto: come
raffigurare ritratti e visi caratteristici*

Translation by Paul Enock at Cicero Translations

Typeset by GreenGate Publishing Services, Tonbridge, Kent

All rights reserved. No part of this book, text, photographs
or illustrations may be reproduced or transmitted in any
form or by any means by print, photoprint, microfilm,
microfiche, photocopier, internet or in any way known or as
yet unknown, or stored in a retrieval system, without written
permission obtained beforehand from Search Press.

ISBN: 978-1-84448-785-1

The drawings reproduced in this book are of consenting
models or informed individuals: any resemblance to other
people is by chance.

Printed in Malaysia

CONTENTS

STOCKPORT LIBRARIES	
C2001870472	
Bertrams	30/07/2012
743.42	CIV
BRA	£8.99

POSING THE MODEL

In order to create a portrait or a detailed study of a person's head, the subject in question has to adopt and maintain a pose suited to bringing out the characteristics of his or her face and which at the same time creates an interesting composition.

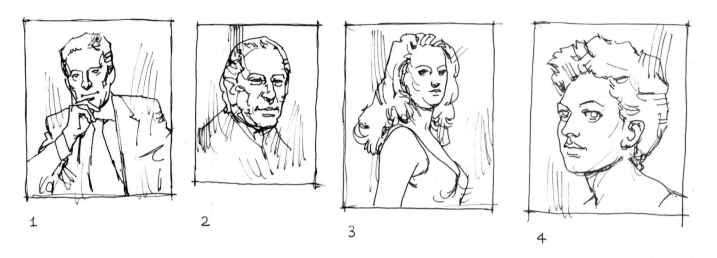

1 2 3 4

CLASSIC OR FORMAL PORTRAIT

In this case, the subject assumes a static, calm or reflective pose – i.e. one inspired by the mainstream tradition of representative portraiture. A three-quarter view of the face is usually chosen under somewhat diffused lighting with a part of the torso included in the composition with the aim of attaining a balanced arrangement in terms of structure and/or tone.

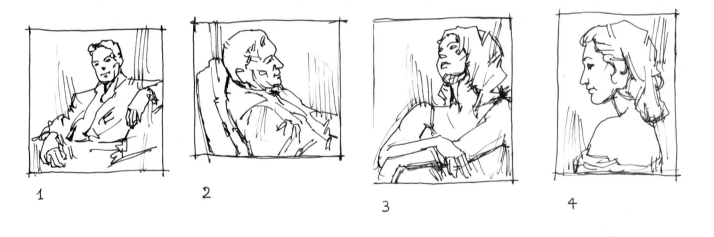

1 2 3 4

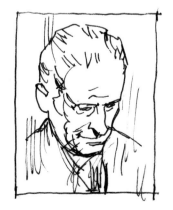

5

INFORMAL PORTRAIT

The artist may decide to break away from the normal traditions and seek out new and unusual ways of organising the picture space. The subject may, then appear 'surprised' in a chance position with a spontaneous, one-off expression, suggesting to the viewer that they are witnessing the person in a passing, unstable position. This kind of composition is usually the result of an impromptu sketch made of somebody seen incidentally.

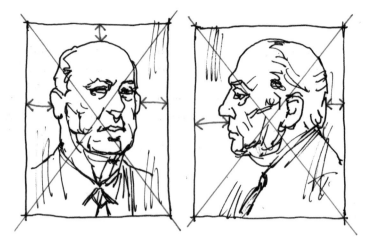

Consider how the subject is placed on the support. A central position is the obvious choice for formal paintings.

COMPOSITIONAL ARRANGEMENTS

Compositions should be avoided in which the head appears too large or too small in relation to the support, in which it seems to gravitate to one side of the frame, or where the head appears incomplete and truncated. These 'rules' cannot, of course, be written in stone: the artist should explore opportune ways of breaking them and thus obtain unusual but interesting effects, as long as this is not done merely for the sake of rule-breaking without any aesthetic justification and is not the result of technical incompetence on the part of the artist.

LIGHTING

Some alternatives for lighting the face:
1 Diffuse lighting
2 Frontal illumination
3 Three-quarter lighting (with the light slightly to one side)
4 Lateral lighting (lighting from one side)
5 Illumination from below
6 Illumination from above
7 Three-quarter/lateral lighting from above
8 Three-quarter lighting from behind

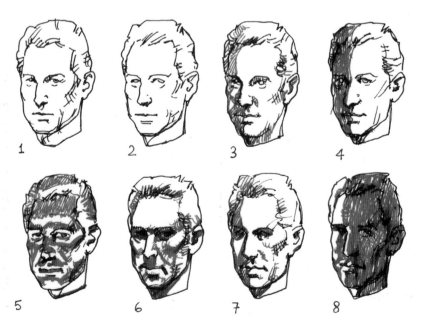

Lighting on the face can be natural or artificial. When sketching people in the street or other public places, you have to adapt to the lighting found in situ and try to turn it to your best advantage, or at least use it as a spur for better ideas. But when you are painting from a model in the studio, the intensity of the illumination and the most suitable kind of lighting to use are of central importance. For example, when creating a 'resemblance portrait', lighting schemes 1, 2, 3 and 5 would be the most advisable, while the other schemes would be suitable when seeking a dramatic effect, more probably in 'generic' face studies.

PAGES FROM A SKETCHBOOK: SKETCHES AND STUDIES FROM LIFE

Public places offer many favourable opportunities for observing the faces of strangers in their many forms, with various expressions and in different positions. An artist should be in the habit of making quick sketches of such subjects from life and should keep a sketchbook and pencil to hand for recording faces and their details. These sketches can be just small 'annotations' jotted down as if for an anonymous portrait. This type of sketching trains the hand and strengthens essential skills of observation. The finished works can be used as suggestive material for more careful compositions. Here are some pages from the sketchbooks I took with me on a trip to Paris. The drawings were made in various circumstances and you may notice how I used these rapid sketches of strangers' faces as the basis for the portraits you will encounter later on in this book.

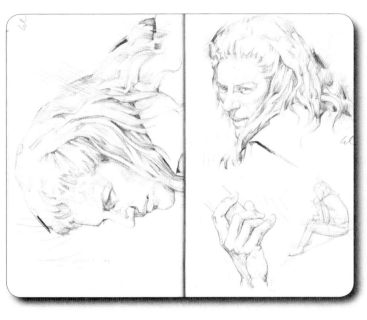

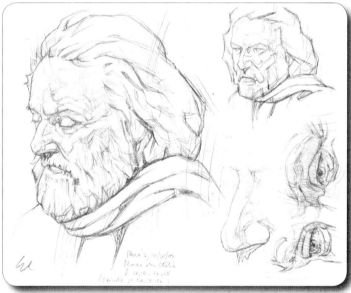

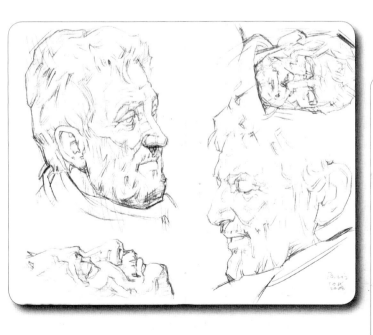

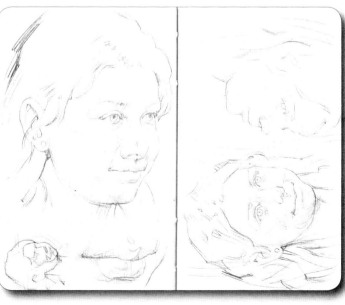

ANATOMY AND EXTERNAL MORPHOLOGY

If the artist knows at least the basics of anatomical structure, portrayals of the human head will be much easier and more precise. Indeed, the shape of the cranium – which differs slightly between the sexes – determines the overall shape of the head and influences individual facial characteristics.

The human cranium is made up of numerous bones that are fused together to form its two component parts: the cranial vault and the facial block. The only moveable bone is the jawbone, which, hinged on its two condyles, is articulated in relation to the cranial vault. The muscles of the facial system are also numerous. Acting on the jawbone are the masticator muscles, including the masseter and temporal muscles, while the much finer cutaneous muscles act on the skin alone, performing such physiological functions as moving the lips or the eyelids. These latter muscles are responsible for the gestural movements of our faces, creating all the nuances of expression by which our physiognomy communicates our psychological states. Both the shape and the size of the cranium are subject to change during our stages of maturation and ageing and this has far-reaching effects on the head's proportions and on individual characteristics, (see the diagrams on pages 36 and 48). Added to this, different evolutionary and environmental influences have led to differences in the cranial shapes depending on ethnicity, as shown below.

The neck should not be overlooked when drawing, painting or modelling the human head, and its muscular structure and dimensions require careful consideration. An accurate copy of the neck conveys the dynamics of the subject's pose and lends vitality and expressiveness to the face. While the head, as a whole, could be geometrically likened to an ovoid in shape, the neck is comparable to a cylinder with two prominent muscle bundles running down its sides: the sternocleidomastoid muscles with the trapezius muscle at the back of the neck.

The external anatomical forms are arranged in layers over the bony structure and show its influence to a great extent.[1]

The eyes are the most immediately significant part of the face: the eyelids cover the eyeballs following their spherical form and, when parted, reveal the iris, the pupil and those parts of the whites of the eyes which indicate direction of gaze. Lips are extremely mobile and expressive, manifesting a large range of our emotions and revealing some aspects of individual character. The lips rest on the half-rounded protuberances of our jawbones and the parting between upper and lower lip runs along a line at approximately mid-height of the upper incisor teeth.

Ears are complex objects but can be simplified with a few lines describing the basic concentric shapes of the exterior auditory cone. Our ears have very precise individual characteristics that become more and more marked with advancing age.

The nose is a prominent feature and should be rendered with solidity but also with fine judgement when evaluating its size and projected shadows.

Hair on the masculine face requires careful treatment – as does the head of hair, which should be depicted in terms of its larger areas of mass and gloss with only a few sparing fine precise lines suggesting the hair's softness, its colour and styling.

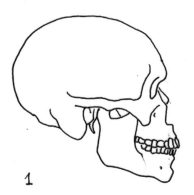

Outlines of crania belonging to the three major human groups (male, lateral view):

1 Negroid
2 Caucasoid
3 Mongoloid

[1] Diagrams showing the principle components of the face are discussed in greater depth in *Drawing Portraits*, an earlier book in this series.

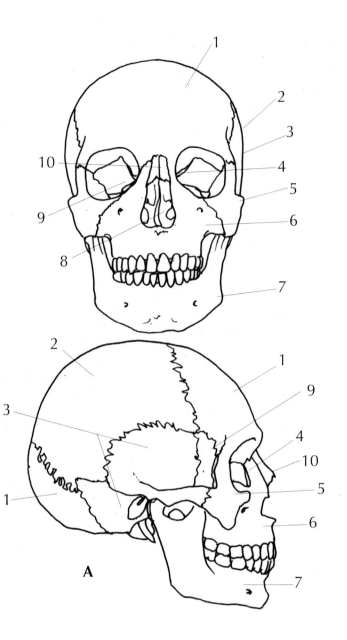

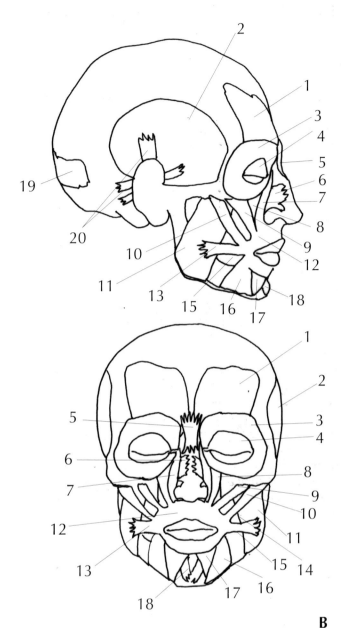

Views of the cranium (A) and of the main superficial muscles (B).

A Bones
1 frontal bone
2 parietal bone
3 temporal bone
4 lacrimal bone
5 zygomatic bone
6 maxilla
7 mandible (jawbone)
8 vomer
9 sphenoid
10 nasal bone
11 occipital bone

B Muscles
1 occipofrontalis
2 temporal fascia
3 orbicularis oculi (and **4**)
5 procerus
6 nasalis muscle
7 levator labii superioris
8 levator labii superioris (infraorbital)
9 zygomaticus minor
10 zygomaticus major
11 masseter
12 orbicularis oris
13 risorius muscle
14 levator anguli oris
15 buccinator muscle
16 triangularis
17 quadratus labii inferioris
18 mentalis
19 occipitalis
20 auricular muscles

METHODS AND MATERIALS

Everything appears to be ready – but something is still missing…

There are various possible approaches to the task of drawing a face; each one is the fruit of tradition and experience as well as of individual artistic attitudes and personal preference. These many approaches can be broadly summarised under the banners of two opposing routes that are centred around two distinct ways of seeing, two diverging accounts of how we perceive what is before us. The first of these routes could be described as 'inductive', so-called because the artist begins by choosing one facial feature to develop – typically one or both of the eyes – and then proceeds to add the other features, while making the necessary measurements for correlating the proportions of one aspect with another. The second route, which could be called the 'deductive' approach, begins with an overall assessment of the shapes of the head or

face seen as a whole, and moves in from the general to the specific, locating the individual details, each in turn, in their correct position within the overall scheme.

Each of these approaches has its advantages, and in practise they alternate and combine with each other. If one approach or another should prevail, this will be in response to the subject's particular features, the pose or the psychological exploratory 'pathway' followed by the artist. The 'inductive' approach, for example, calls for patience and discipline in comparing the relative dimensions of the facial features and assessing the distances between them: the whole is reached via an accumulation of the scattered parts and this means that even the slightest error in judging a distance will be enough to throw the entire outcome into disarray. The deductive approach is perhaps to be preferred because it is more in keeping with the artistic vision, which sees forms first as wholes and then proceeds to investigate the way in which they are put together.

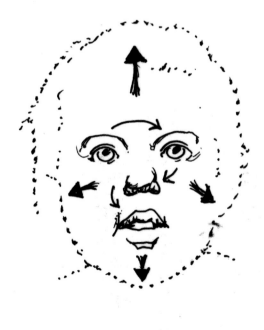

From the specific to the general: (the inductive approach) – working from the centre outwards to the overall outline.

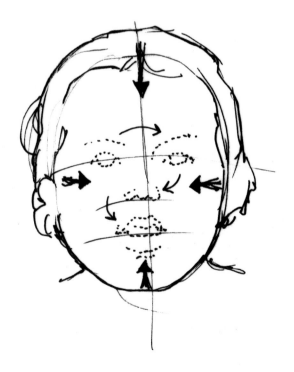

From the general to the specific: (the deductive approach) – working from overall outline inwards to the central details.

Other matters affecting the choice of approach include the way the face is perceived, the aesthetic effect the artist is trying to achieve and which graphical medium is the most suitable for obtaining this effect in pictorial form. The face may be perceived synthetically, i.e. concentrating on its principal larger structures at the expense of internal details, or it may be perceived analytically, i.e. giving a full portrayal of every tiny detail making up its overall form, leading to a definitive rendition of individual particulars in an almost scientific way. Either of these tendencies can be given a more or less linear treatment. At one extreme, depiction is realised by means of line alone: almost scalpel-like, the line investigates the face's forms and structures without any help from tonal nuance. At the other extreme, using chiaroscuro, it is only the modulation between areas of light and dark that render the form without using any directly drawn outline. When combined, these two approaches will complement each other.

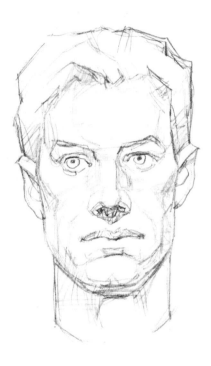

Synthetic (using large masses)

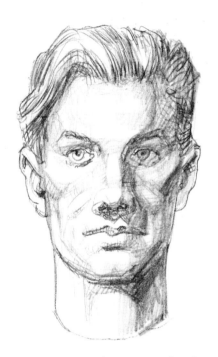

Analytic (using details)

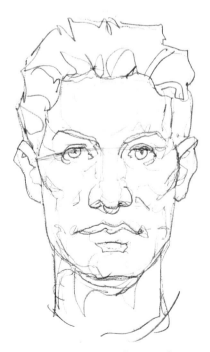

Linear (using lines only)

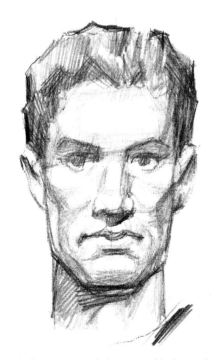

Tonal (using modulations of light and dark only)

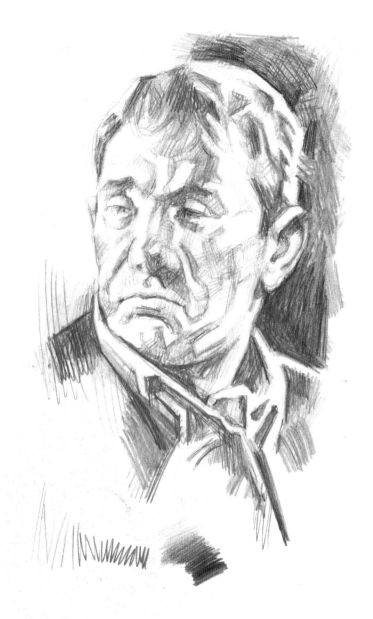

The **pencil** is the most commonly used tool for any type of drawing because it is ideal for spontanious expression, is easy to use and capable of great precision. Pencils can be used in both highly finished works and for a quick thumbnail sketch to be kept for future reference. I find mechanical propelling pencils suitable for the former and softer leads of greater cross-section for the latter purpose. Both propelling pencils and traditional wooden-sheathed pencils are graded according to hardness: from the very hard 9H, which leaves a very faint, pale line to the very soft 6B, whose broad, bold marks can vary readily according to the hand-pressure applied.

Ink is a medium widely used by artists. It can be applied to the paper using a brush or pen nib and special effects can be obtained using, for example, bamboo nibs, broad-nibbed pens, calligraphic pens, technical drawing pens (e.g. Rapidograph), felt-tipped pens and ballpoints. Tonal strength is usually varied by decreasing or increasing the spacing between lines of cross-hatching and varying the linear angle. For this reason, when drawing with a pen, it is a good idea to choose good-quality smooth-surfaced paper or card in order to avoid the nib snagging on the paper's surface and leaving ink blotches behind. A variation of the ink medium is the 'dry-brush' technique, which consists of brushing with the point of a soft, almost dry brush across the surface of the paper to leave an open-textured, nebulous effect.

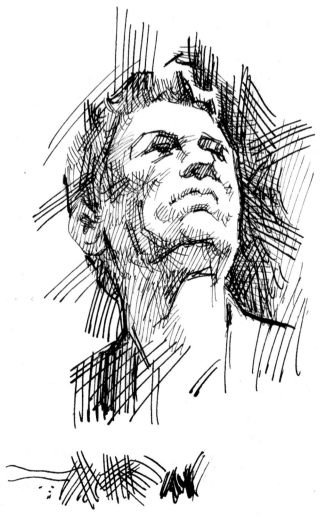

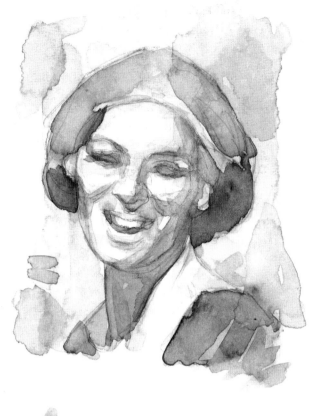

When diluted with the appropriate proportions of water, **watercolour paint**, water-soluble inks, aquarelle pencils and Indian ink will all produce a rich range of subtle tones, which are well-suited to executing studies of the human face and head. The method could follow the classic techniques of watercolour painting, or these media can be used as tonal supplements for drawings made in pencil or ink. A single watered-down colour can also achieve nuances of tonal gradation, (as with the lavis technique). The same effects can be obtained by using Indian ink (half-tone) – with the objective of concentrating attention on the play of light and shade on the structural form, rather than on obtaining chromatic effects. Watercolour technique requires a progression from lighter to increasingly darker tones to retain the transparency of the colours; the gradual building up of layers of paint still allow the luminous whiteness of the paper to shine through.

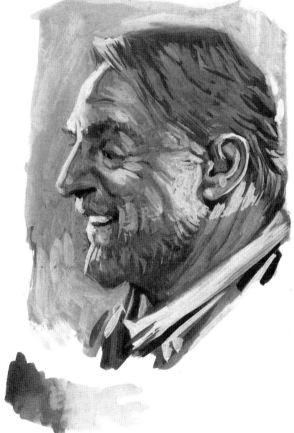

Gouache (or tempera) is a very attractive medium that can take on purely graphical qualities, offering properties midway between those of watercolours and those of oils or acrylics. As with watercolour, the paint is diluted to the required density using water (although if white is added this will also lighten the shade of a colour) before being applied using a brush made from hair. As with oil paint, a thinned wash will permit the application of a quick-drying glaze, while paint laid down in a thicker consistency – which will also dry relatively quickly – will cover and hide underlying layers in one go. This allows you to work both spontaneously with free-flowing brushstrokes and also to execute high-resolution, clear and detailed work. Gouache paint can be applied to just about any surface that has some key and is not water-repellent. This includes paper, card, canvas, canvas-board and many others. The surface of the finished work has a pleasing matt look. Gouache lends itself to mixed-media work with pen and ink, graphite, charcoal and coloured pencil.

Each of the above techniques offers its own characteristic properties that enable artists to give free rein to their creative temperament while painting or drawing a picture. In the examples shown on the following pages, I have divided the process of creating a portrait into five consecutive steps, which I hope are sufficiently self-explanatory in the way they indicate a step-by-step method for depicting the shape of the head.

This is one of the many intuitive and rather scholastically procedural approaches to executing a work; approaches which have nonetheless proven themselves to be very useful in helping artists to start portraying any type of subject successfully.

The procedure consists of the following stages:
Step 1 Set down a concise but accurate indication of the overall dimensions and the main proportional relationships.
Step 2 Indicate the structural volumes.
Step 3 Fill in the areas of shadow in a simplified way.
Step 4 Modulate the light and dark tones more fully.
Step 5 Continue to work on tone and detail until the desired effect has been attained. Once the use of the medium, the method and the way of 'seeing' has been mastered, each artist will then find his or her own personal style of expression and working sequence.

STEP-BY-STEP EXAMPLES: PENCIL

Step 1

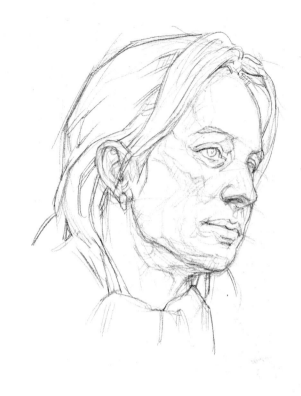

Step 2

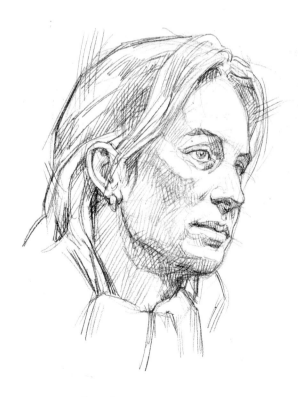

Step 3

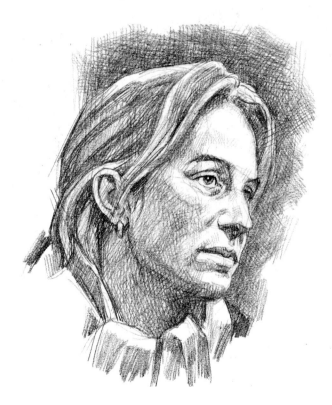

Step 4

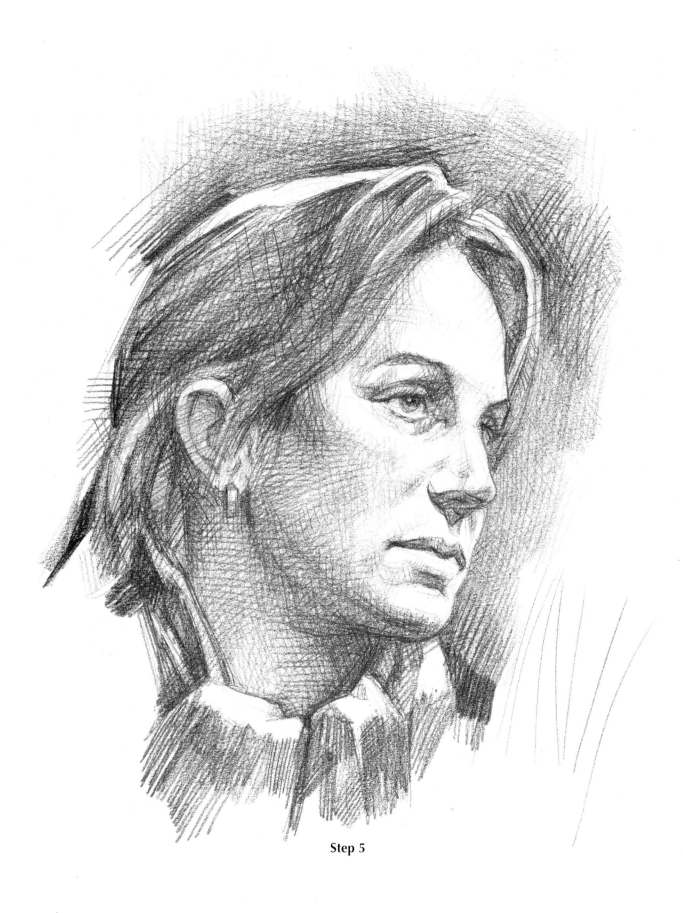

Step 5

HB and B pencils on paper, 21.5 × 30.5cm (8½ × 12in)

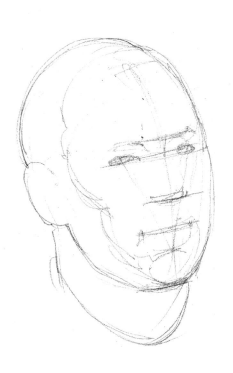

Step 1

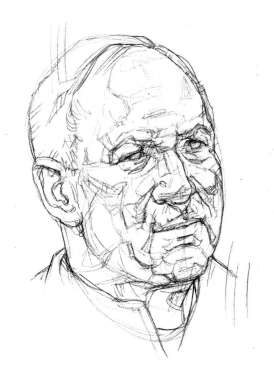

Step 2

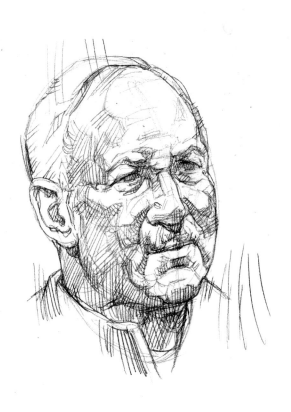

Step 3

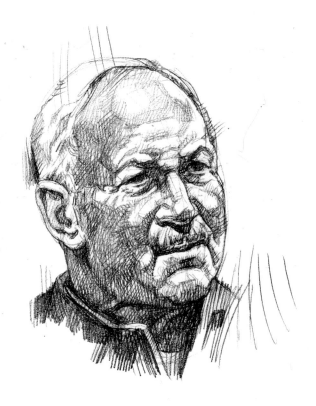

Step 4

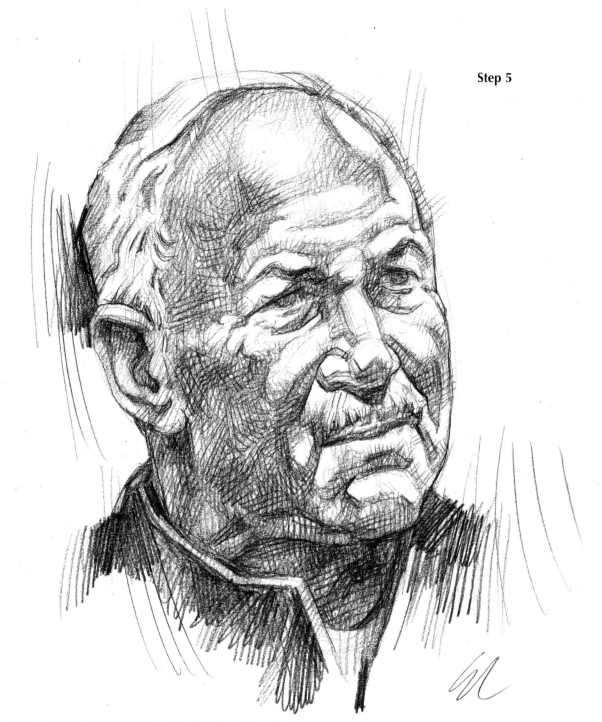

HB and B pencils on paper, 21 × 30cm (8¼ × 12in)

Preliminary outline in pen and ink on paper

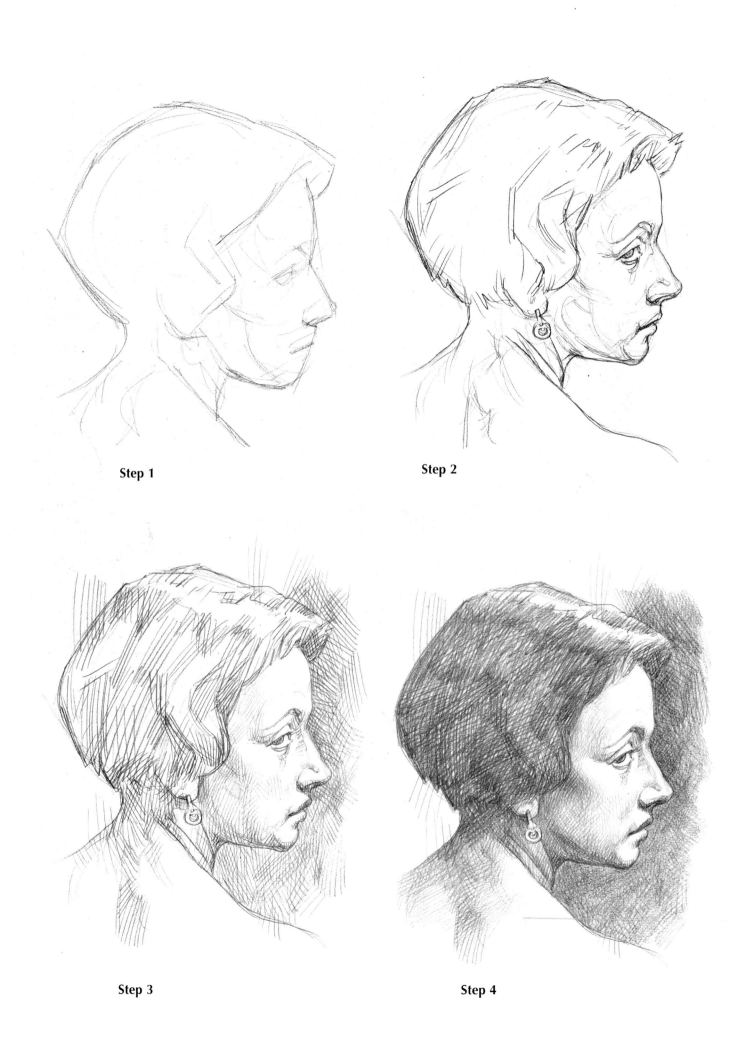

Step 1

Step 2

Step 3

Step 4

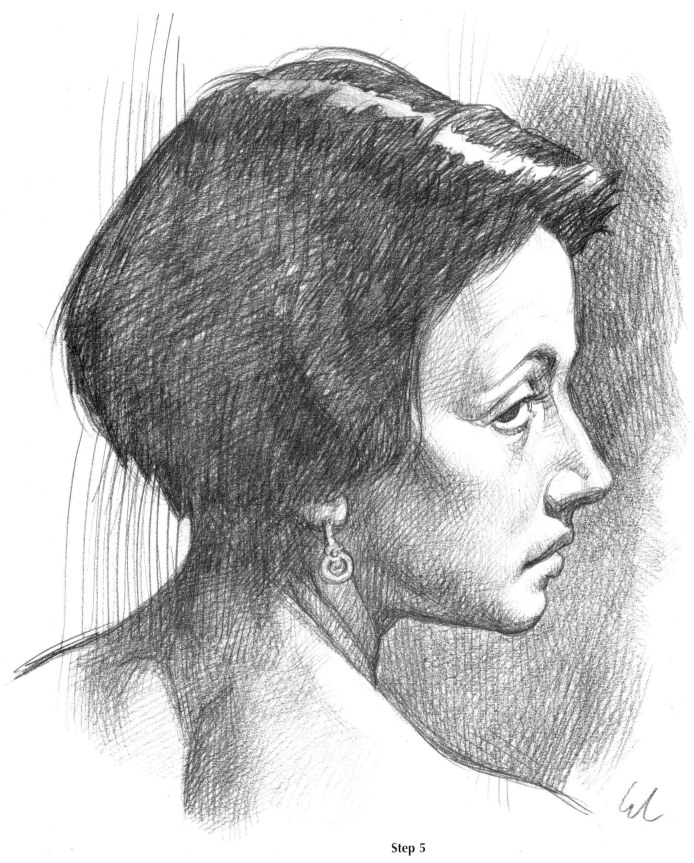

Step 5

HB pencil on paper, 30 × 21cm (12 × 8¼in)

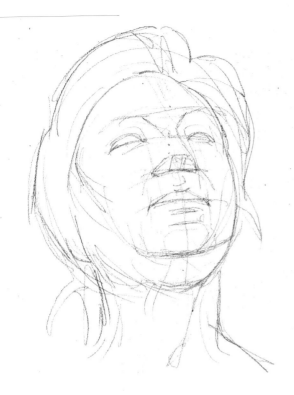

Step 1

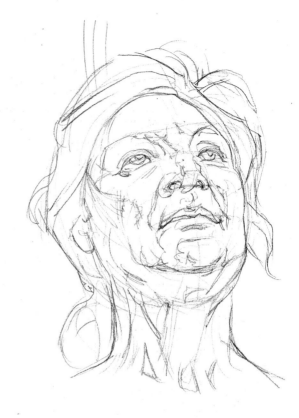

Step 2

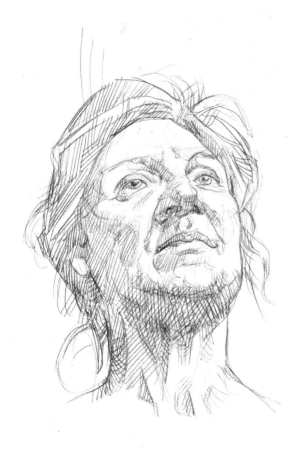

Step 3

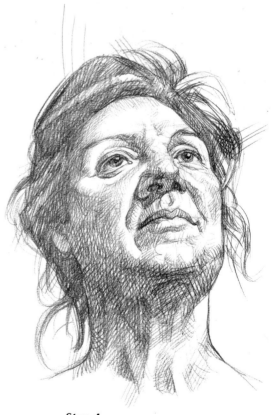

Step 4

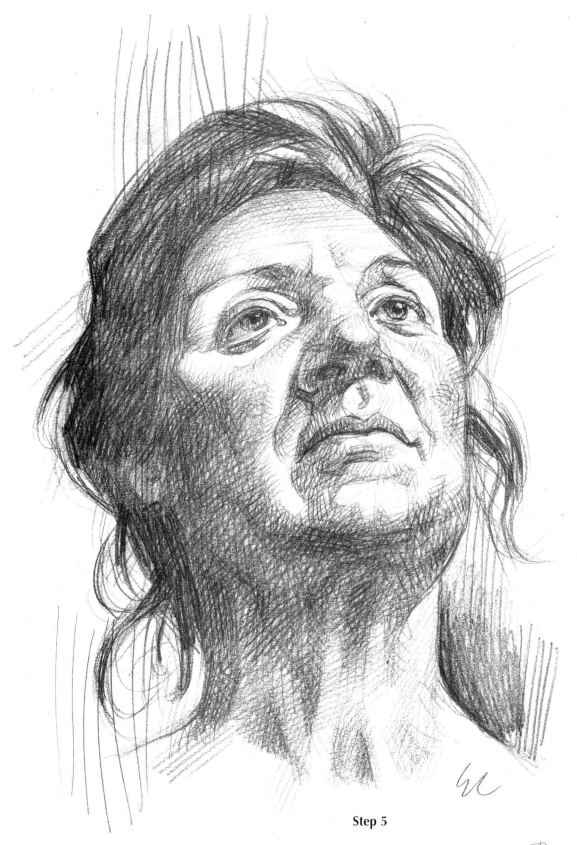

Step 5

HB and B pencils on paper, 21 × 30cm (8¼ × 12in)

Preliminary outline in pen and ink on paper

STEP-BY-STEP EXAMPLES: WATERCOLOUR

When using watercolours, the colours should be added to the picture in successive layers, using the same method as when achieving transparency effects, and moving from pale tones to darker ones. The initial drawing (step 1) should be very brief and the outline drawn very lightly so that it will not show through the colour.

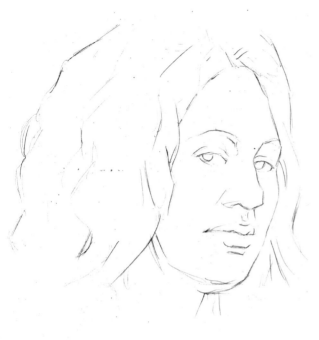

Step 1

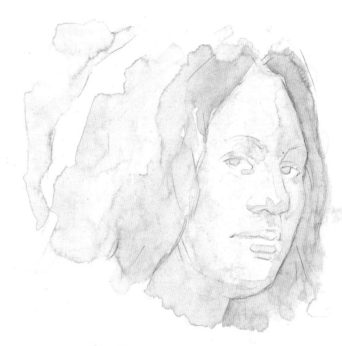

Step 2

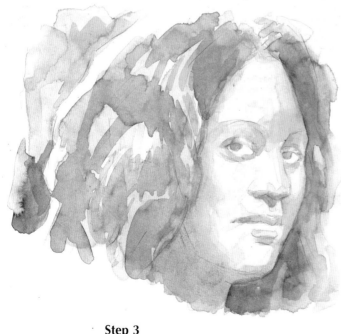

Step 3

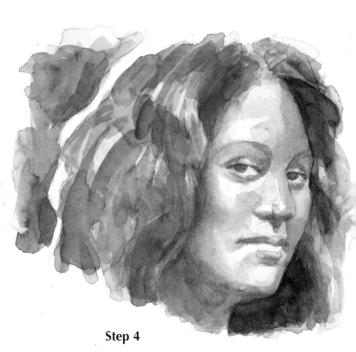

Step 4

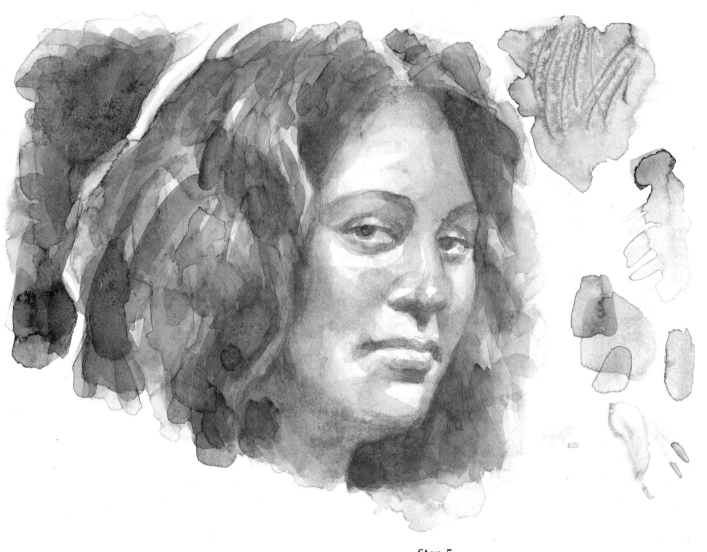

Step 5

Monochrome watercolour (sepia) on paper, 30.5 × 21.5cm (12 × 8½in)

In the initial drawing, it is best to avoid any rubbing out or drawing over existing lines because this could damage the paper's surface and lead to an uneven spread of paint.

An alternative is to prepare the initial sketch on tracing paper and then trace just the essential outlines on to the surface of the finished work.

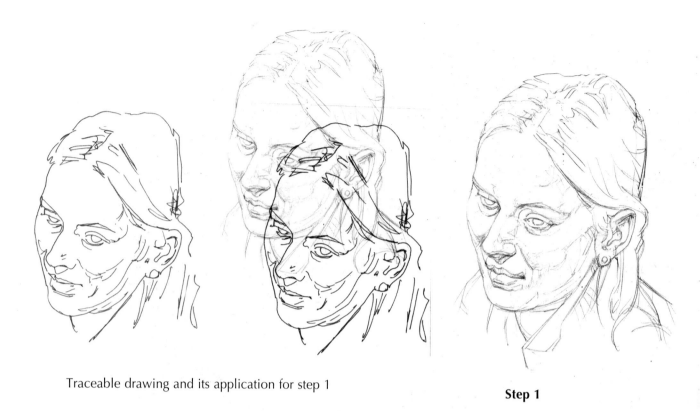

Traceable drawing and its application for step 1

Step 1

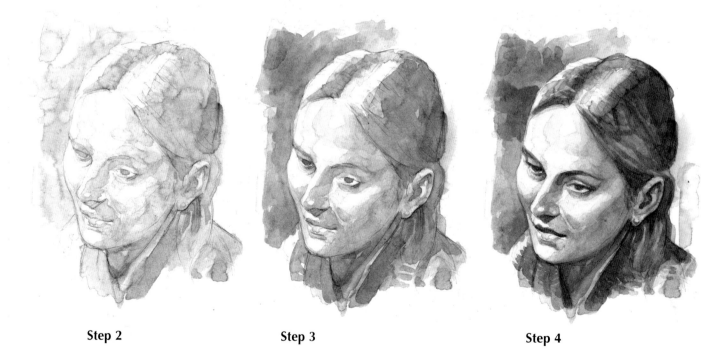

Step 2 **Step 3** **Step 4**

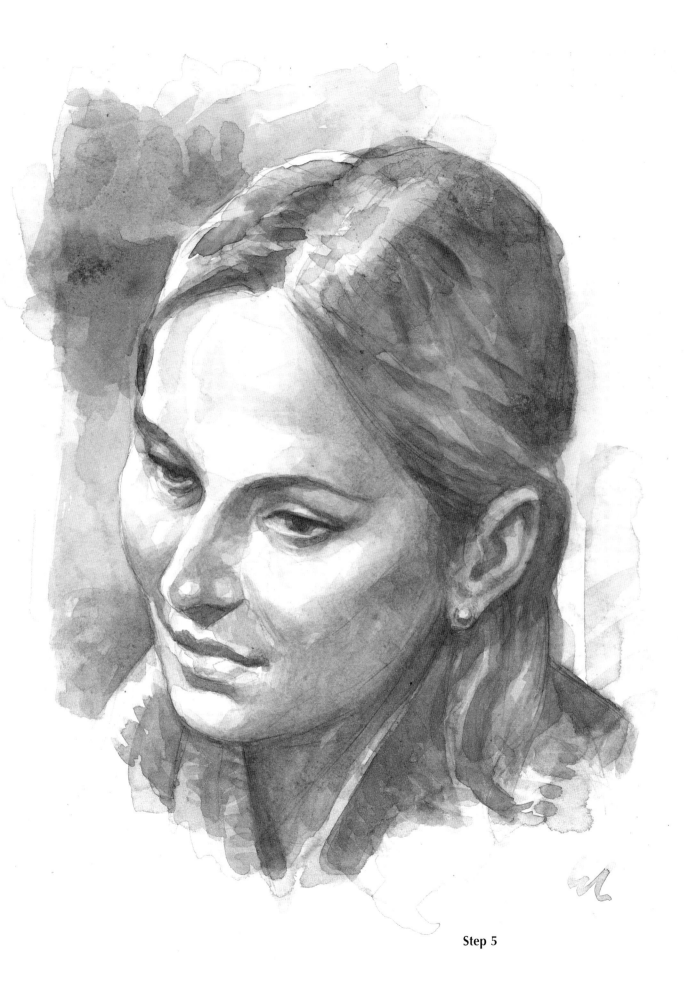

Step 5

Monochrome watercolour (raw sienna) on paper, 21 × 30cm (8¼ × 12in)

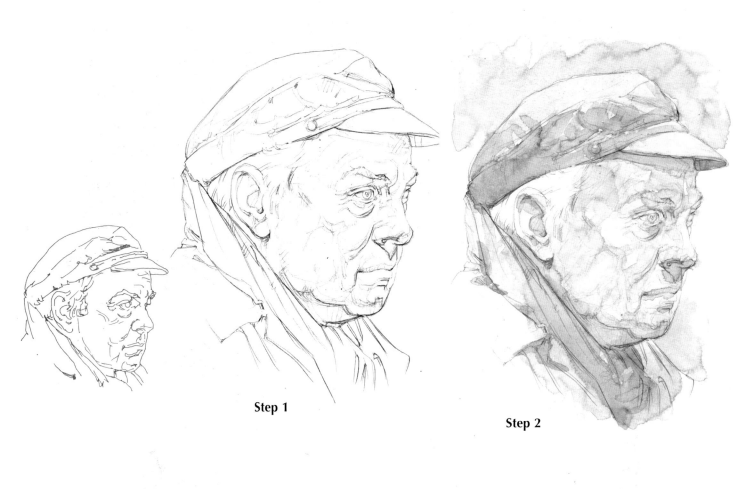

Step 1

Step 2

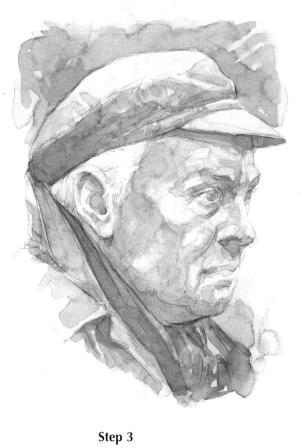

Step 3

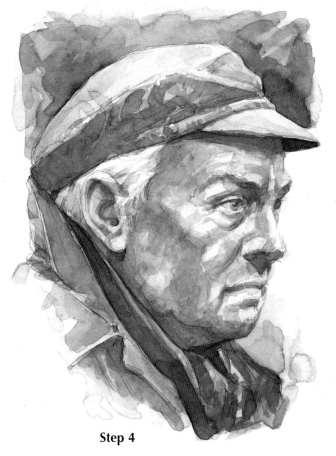

Step 4

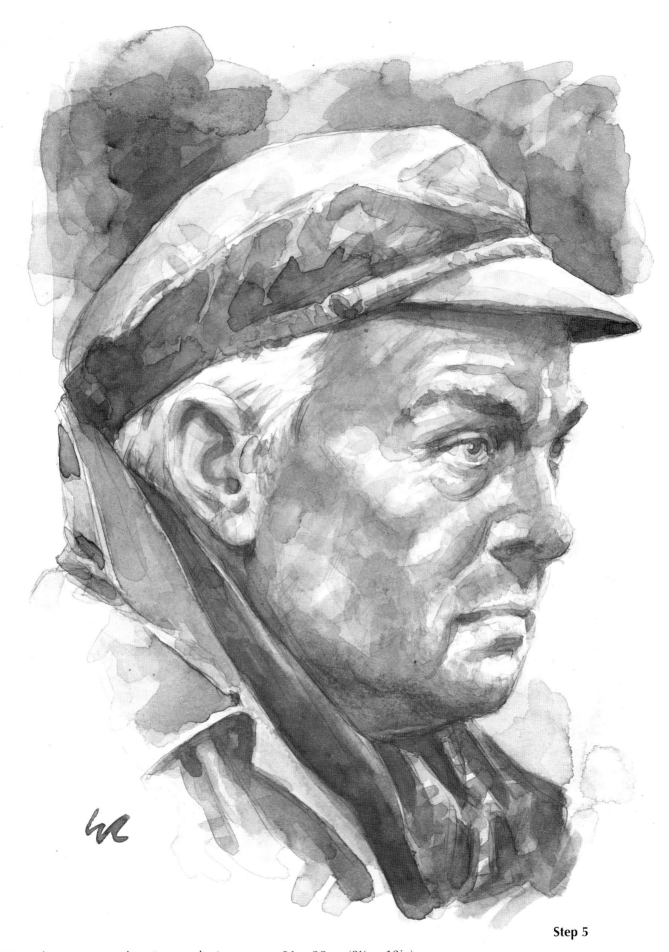

Step 5

Monochrome watercolour (raw umber) on paper, 21 × 30cm (8¼ × 12in)

STEP-BY-STEP EXAMPLES: GOUACHE

Gouache paint covers well (see page 13), especially if applied quite thickly. For this reason you can allow yourself to use bold strokes in the initial stages even when working directly on the final surface, and it is possible to work both from dark to light and from light to dark tones.

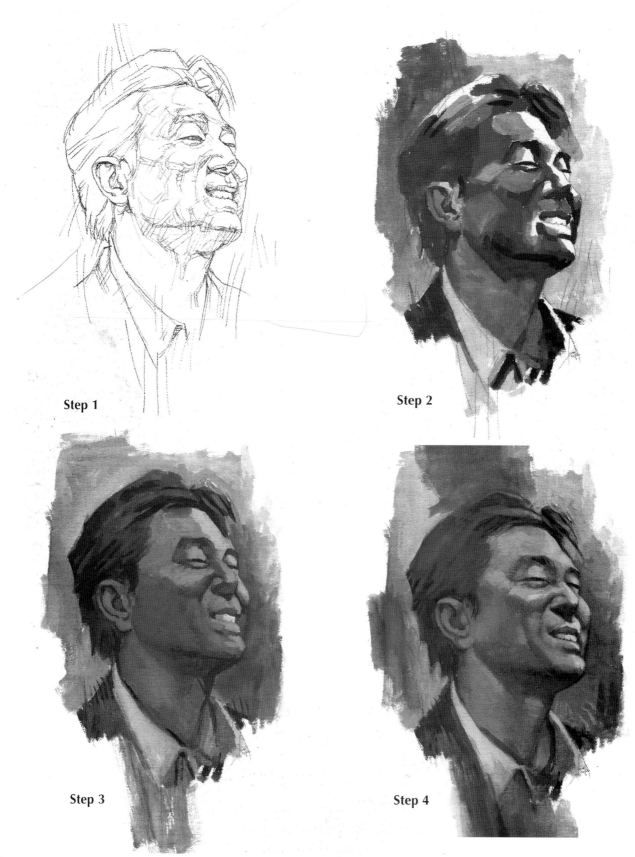

Step 1

Step 2

Step 3

Step 4

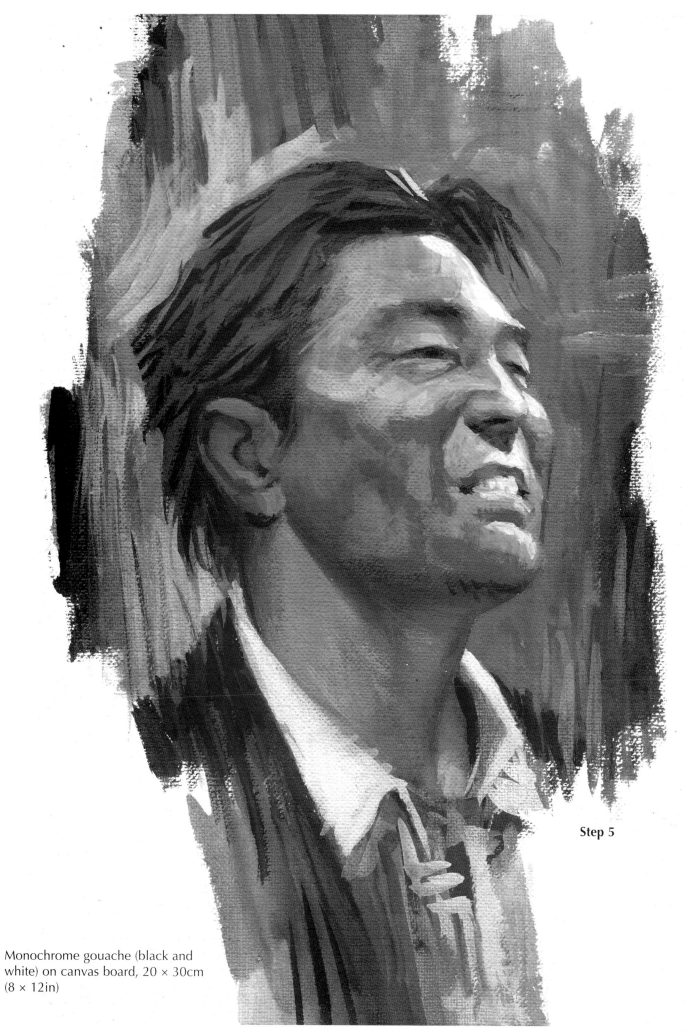

Step 5

Monochrome gouache (black and white) on canvas board, 20 × 30cm (8 × 12in)

Step 1

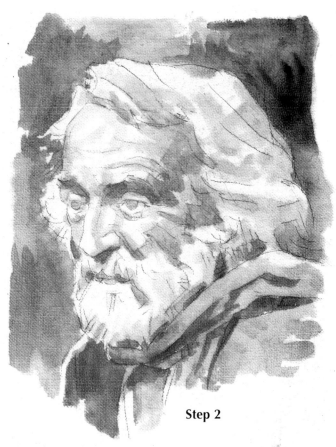

Step 2

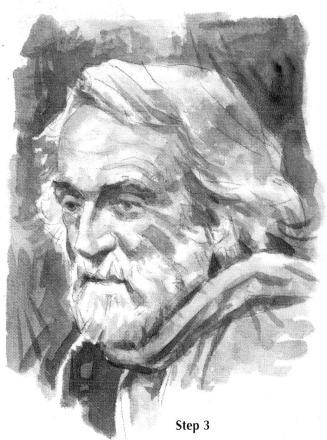

Step 3

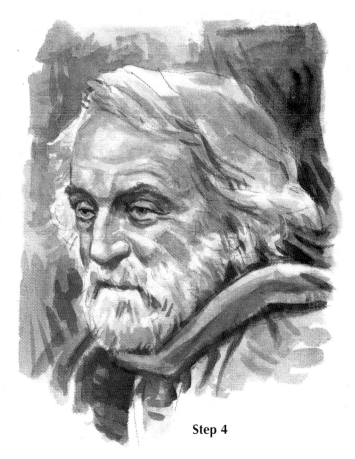

Step 4

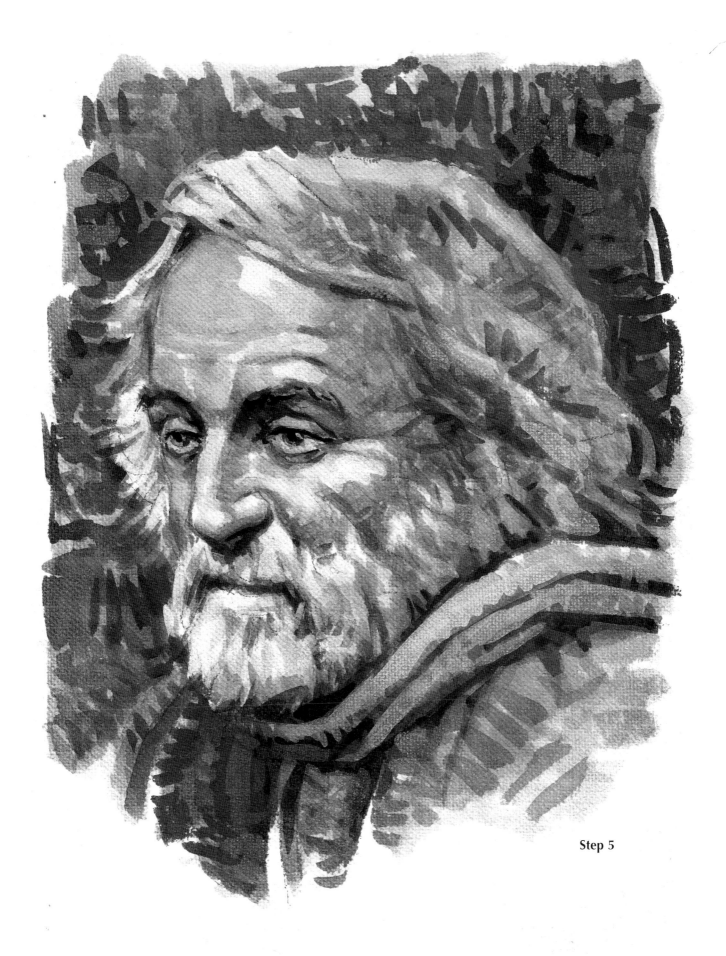

Step 5

Monochrome gouache (black and white) on canvas board, 20 × 30cm (8 × 12in). For this painting, I used a highly diluted, watery paint to attain effects similar to those of watercolour. In a few places (on the scarf, in the hair and on the eyes, for example) I used slightly thicker paint.

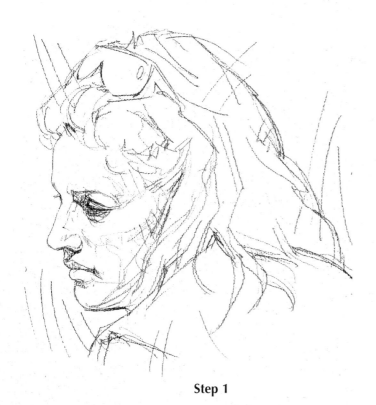

Step 1

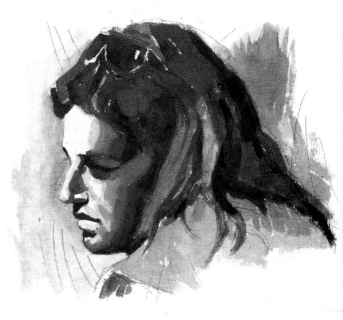

Step 2

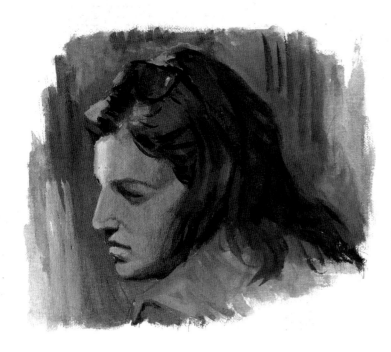

Step 3

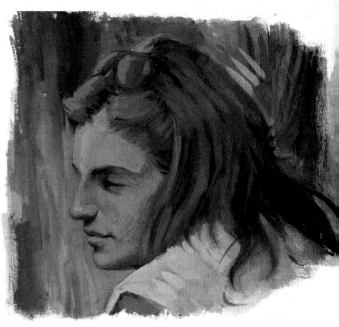

Step 4

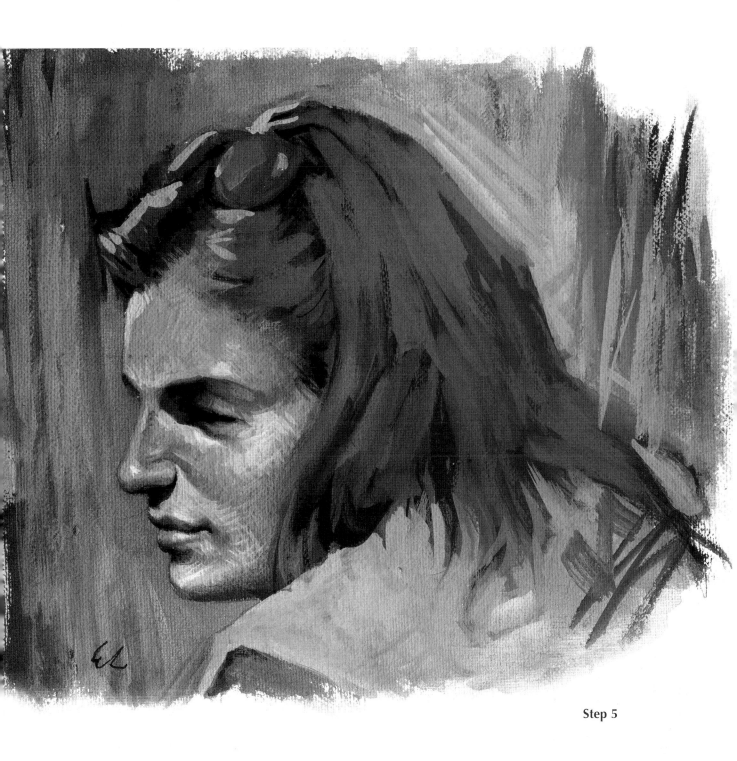

Step 5

Monochrome gouache (black and white) on canvas board, 30 × 20cm (12 × 8in)

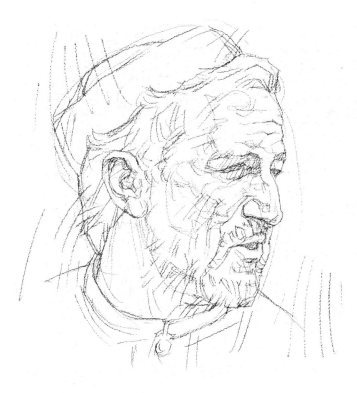

Step 1

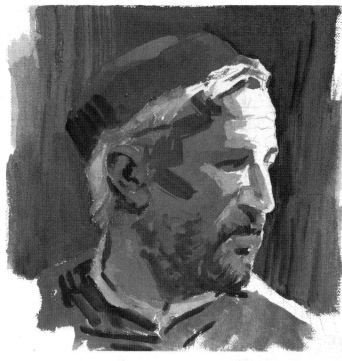

Step 2

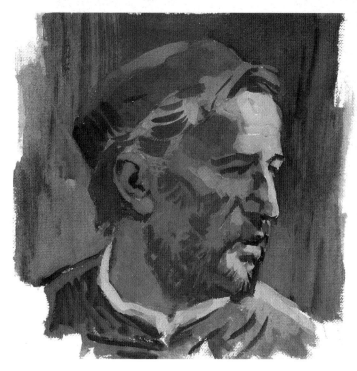

Step 3

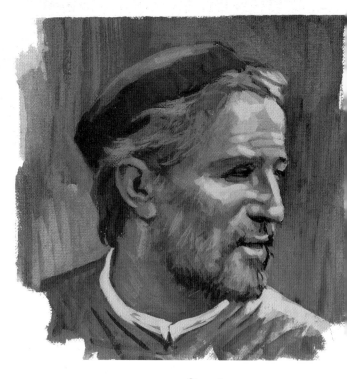

Step 4

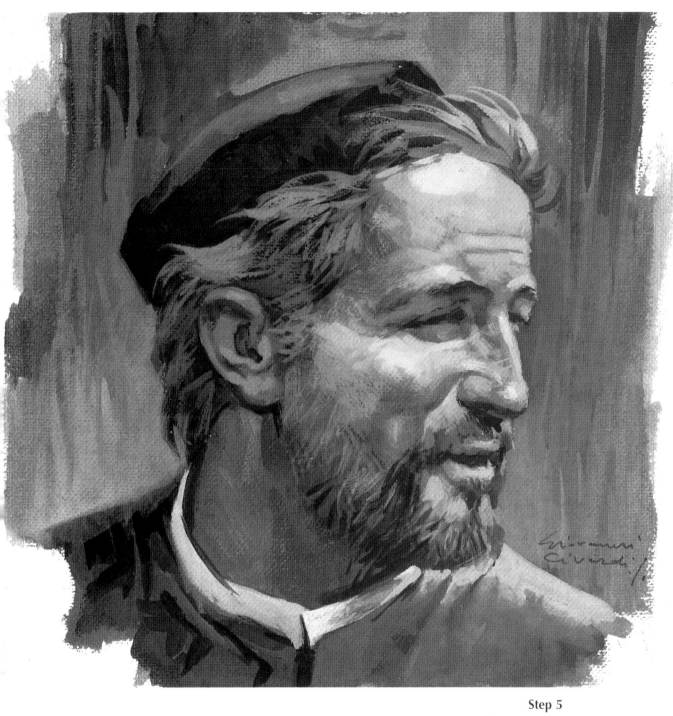

Step 5

Monochrome gouache (black and white) on canvas board, 30 × 20cm (12 × 8in)

HEADS AND FACES OF ADULTS

The faces of adults in their prime (20–50 years of age) are a rich source of study material for the artist, especially for artists who are setting out to tackle the great themes of the portrait and the human figure. The reasons for this are many: the facial features have by this age become definite and well delineated; the face's anatomical structure and proportions fully conform to standard types; the face's expressive characteristics now appear with their full range of meaning.

People's heads vary enormously in size, in their characteristics and in their shapes, but they can all be brought within a useful proportional framework that is helpful for simplifying the face's forms and coordinating its structures. If we draw two horizontal lines – one passing along the line of the eyebrows and the other touching the base of the nose on a 'generalised' person's head, whether male or female, we will find that the face, from the hairline on the forehead down to the base of the chin, can be divided into three sections. In the frontal view, two vertical lines passing through the centres of the pupils will enclose the narrower forms of the nose and lips.

Body build varies from person to person but, in general, there are three main types: 'short-limbed', for a short and compact stature, 'long-limbed', for tall and thin and 'normal build' for builds somewhere between these two. The head, too, will follow the characteristics of body type, with many nuanced variations in between: as we all know from experience, people's heads and faces may vary between the above categories to take on the shapes generally described as round, square, wide and low-cast or long and narrow.

Even though the framework below applies equally to the faces of adult males and females alike, it is worthwhile noting some typical differences between the two sexes in the overall shaping of the head. A woman's head tends to be more rounded in form, with a lower and less expansive distribution of facial features and the female forehead tends more to the vertical, while the angle of the jawbone is more rounded than that of the male. Women tend to have more abundant heads of hair and their necks tend to be more slender than those of men.

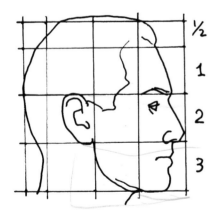

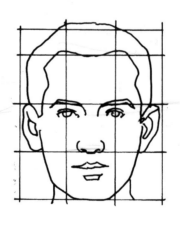

A

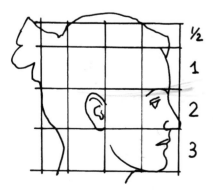

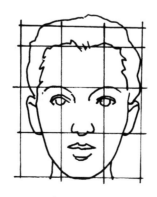

B

'Standard' proportions of the adult head and face:
A male
B female

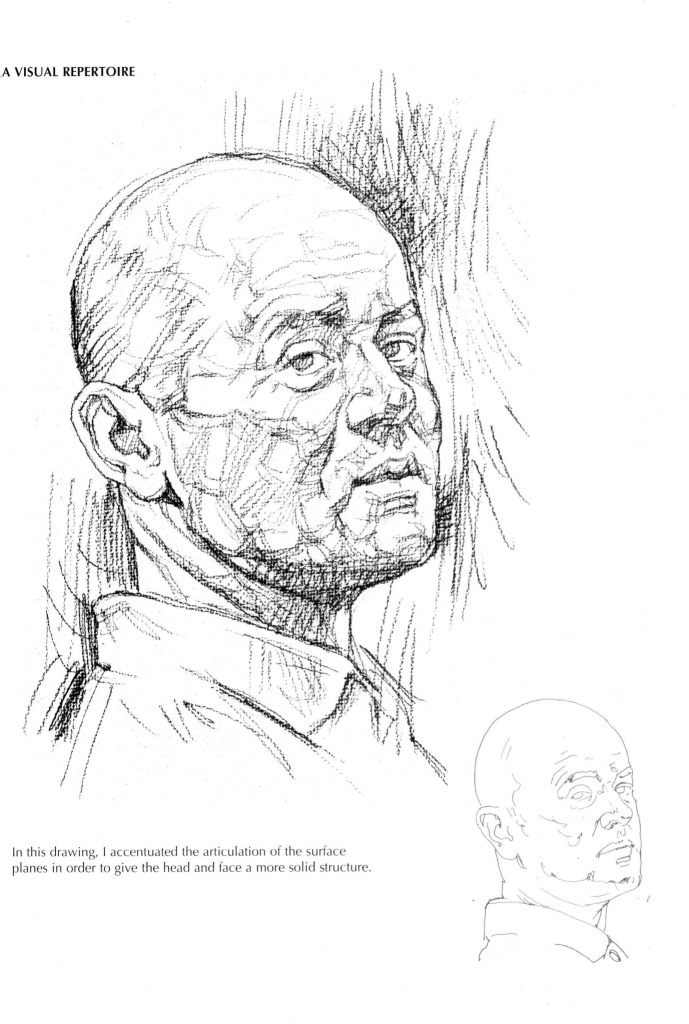

In this drawing, I accentuated the articulation of the surface planes in order to give the head and face a more solid structure.

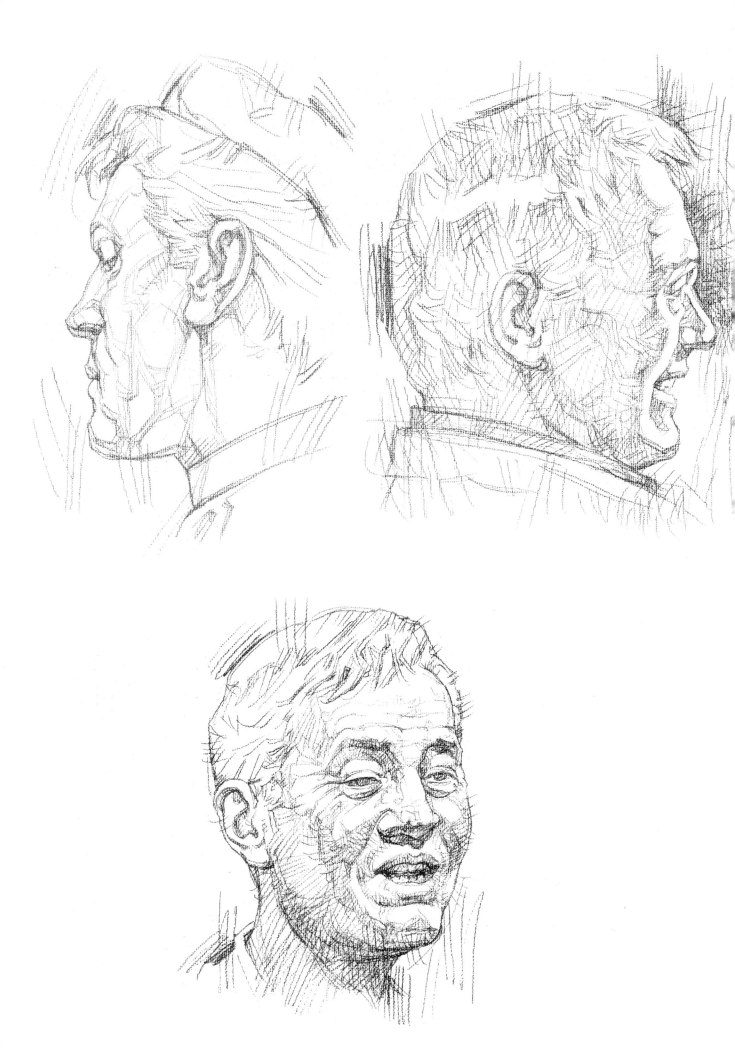

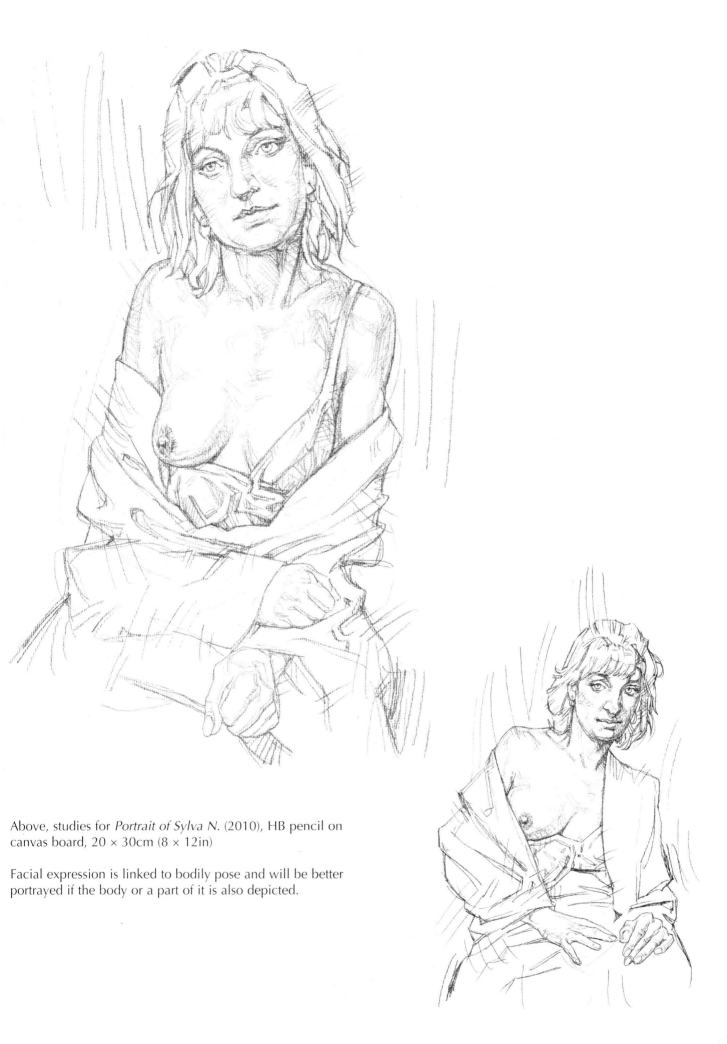

Above, studies for *Portrait of Sylva N.* (2010), HB pencil on canvas board, 20 × 30cm (8 × 12in)

Facial expression is linked to bodily pose and will be better portrayed if the body or a part of it is also depicted.

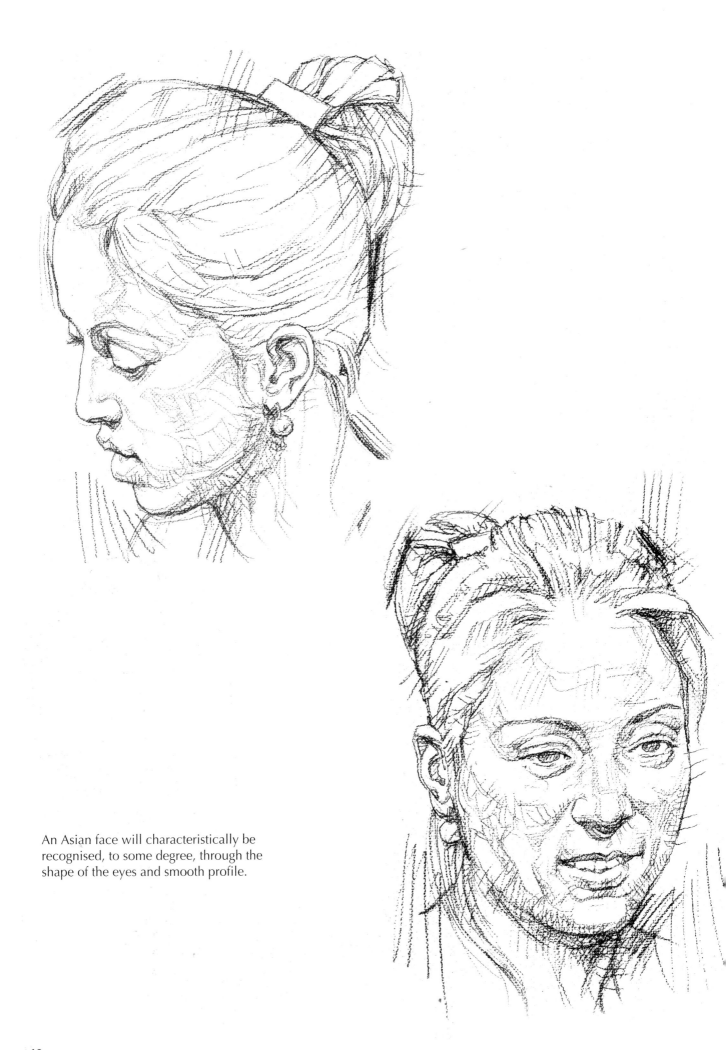

An Asian face will characteristically be recognised, to some degree, through the shape of the eyes and smooth profile.

HB mechanical pencil on canvas board, 20.5 × 30.5cm (8 × 12in)

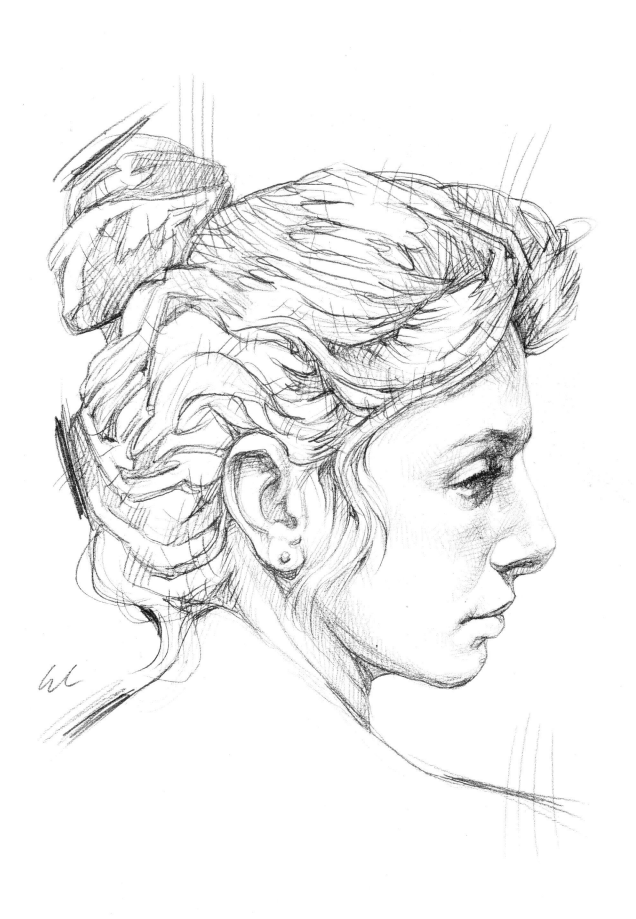

Portrait of Rosanna F. (2010, second version), HB pencil on paper, 31 × 21cm (12¼ × 8¼in)

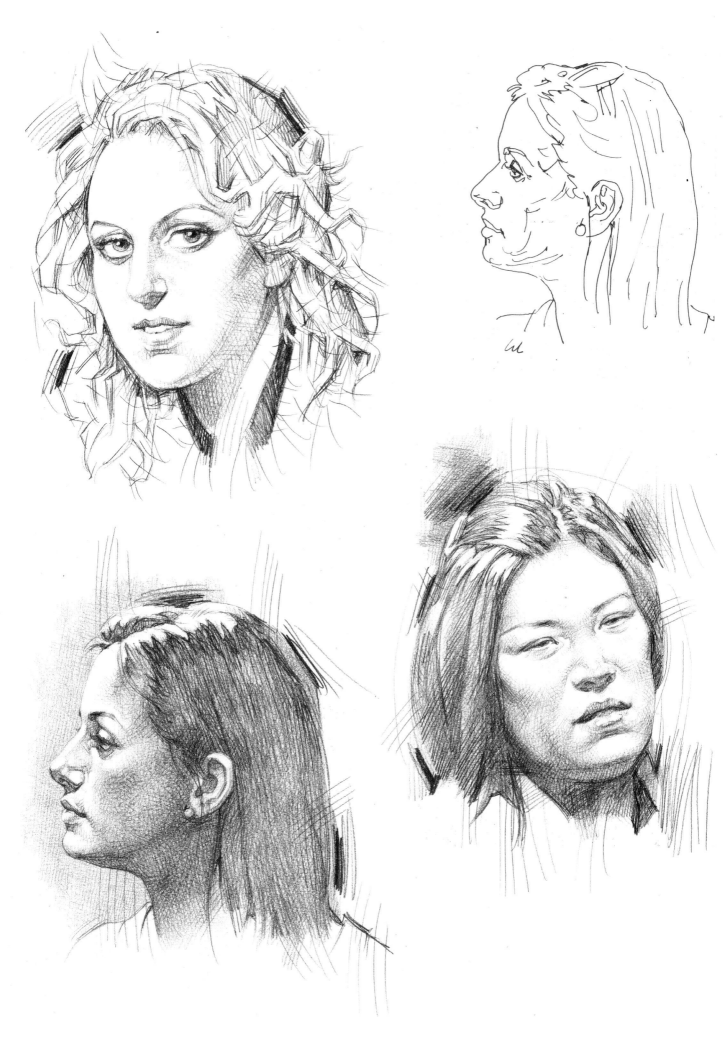

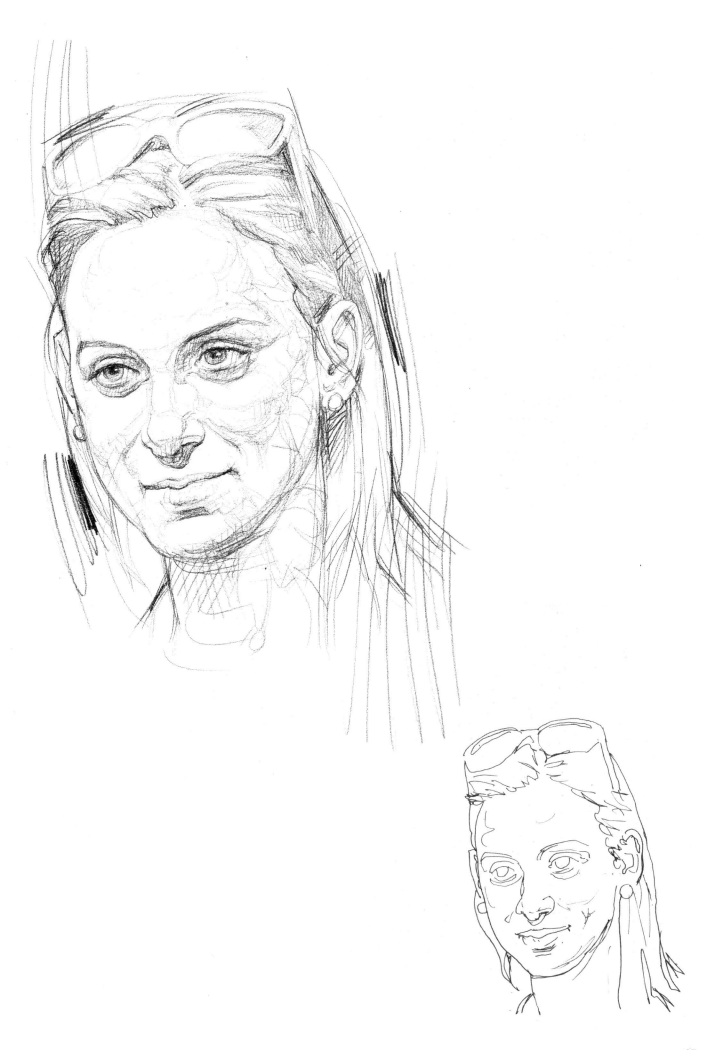

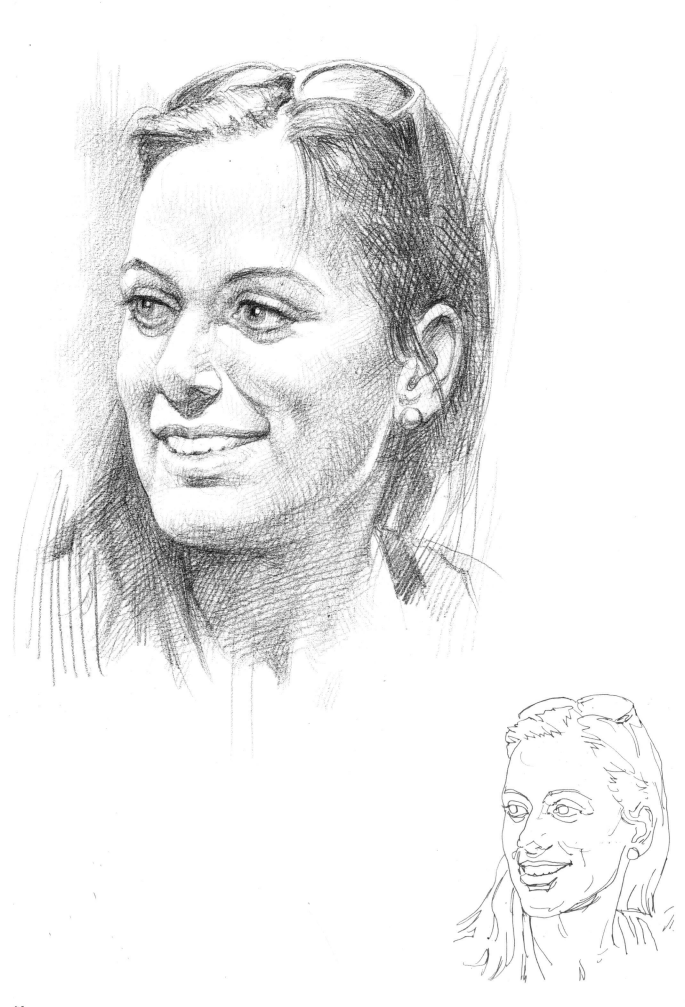

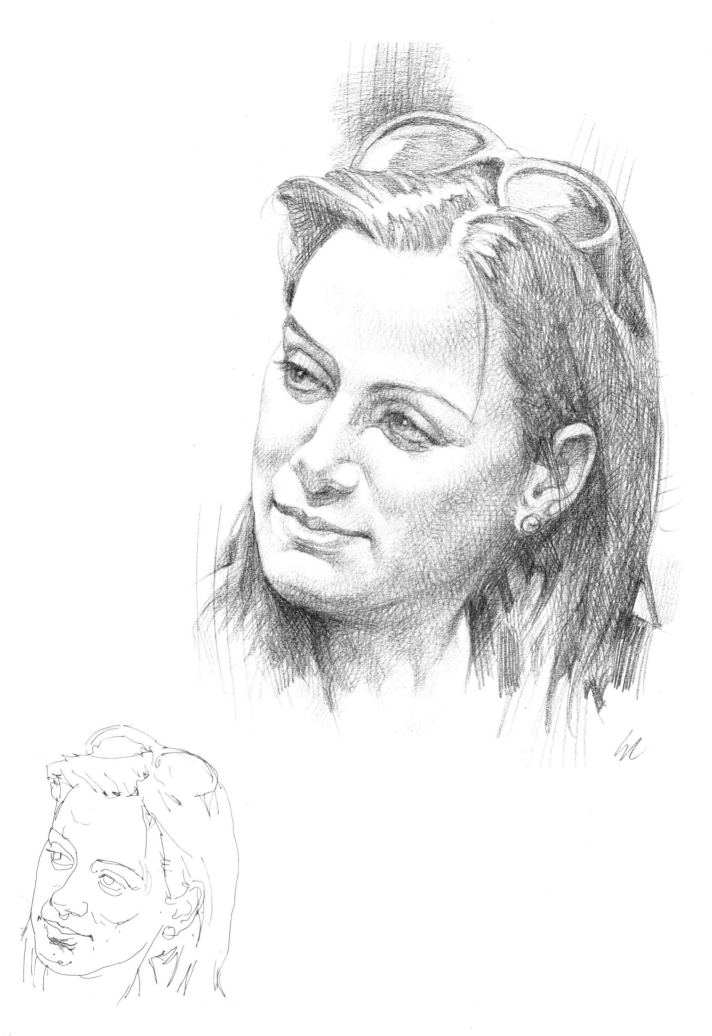

HEADS AND FACES OF INFANTS AND YOUNGSTERS

Always pursue your dreams – but stop before you reach them…

A drawing of the head and face of a child or an adolescent is based more on an analysis of proportions than on muscle anatomy. The proportions of an infant's head are indeed very different from those of an adult and they vary visibly as the child grows. The cranial vault is very rounded at birth, its size dwarfing that of the face, and this has the effect of making the eyes appear much larger.

The gradually changing proportions of head and face provide a visual indicator of the child's age. Particular attention should be paid, for example, to the length and shape of the nose, the position of the line formed by the eyebrows, the proportions of the ears (which may seem oversized) and the neck (which is slender and tubular in appearance), as well as the small, rounded chin. Make a mistake in your observation of the proportions and you run the risk of creating a drawing of an adult in miniature.

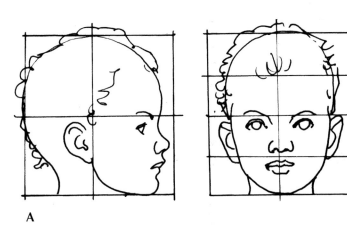
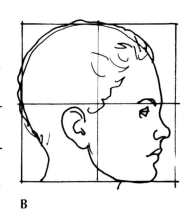

A

B

Grid for the proportions of the head and face of a child: at around two years old (A) and around 7 to 8 years old (B).

The proportional relations remain similar for the sexes until at least adolescence.

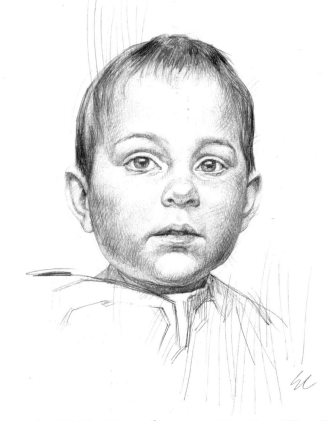

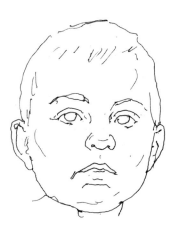

Portrait of N. (2010), HB pencil on paper, 22 × 31cm (8¾ × 12¼in), with a structural guide in pen and ink

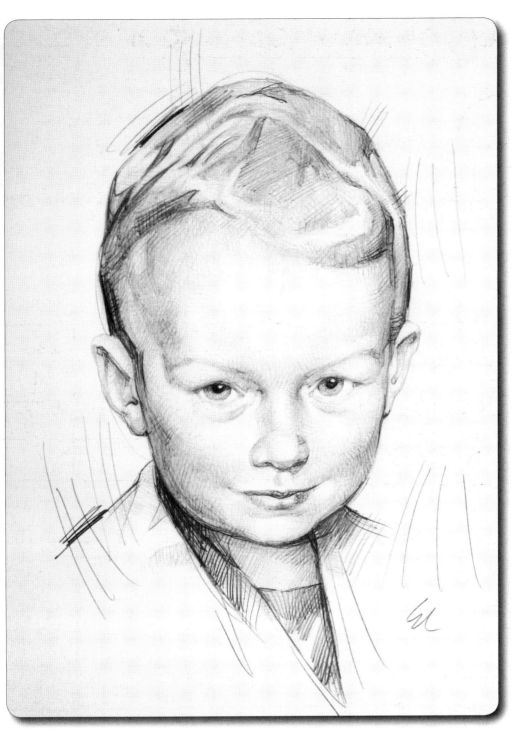

Portrait of W. (2010), HB pencil on paper, 22 × 31cm
(8¾ × 12¼in), with a structural guide in pen and ink

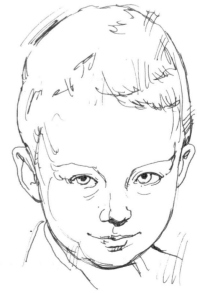

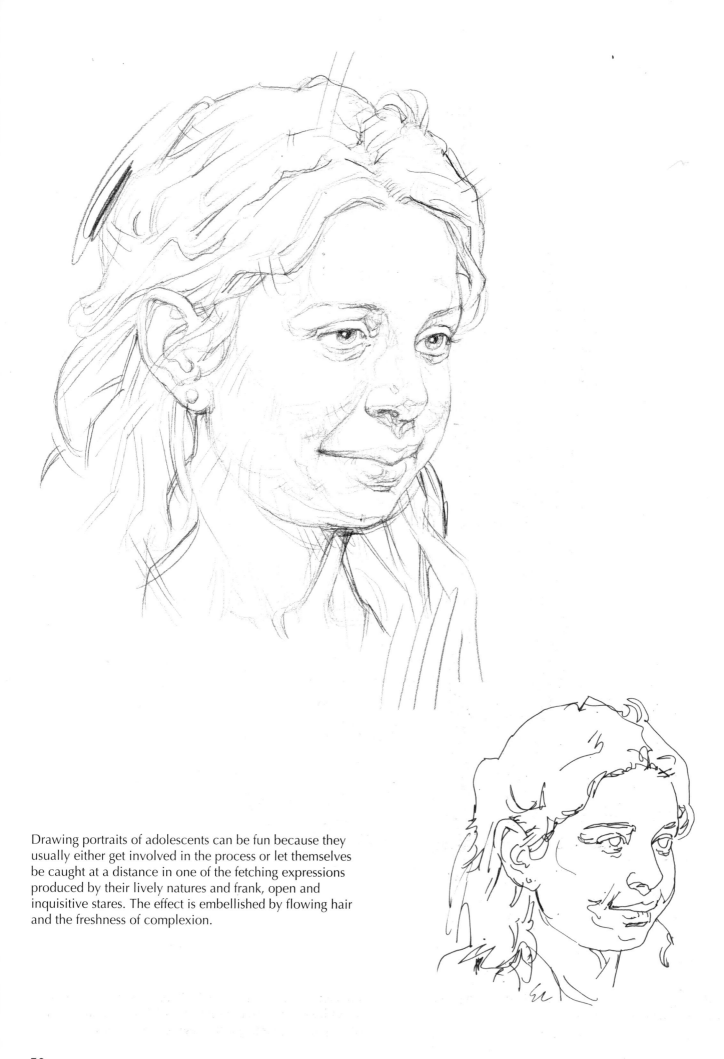

Drawing portraits of adolescents can be fun because they usually either get involved in the process or let themselves be caught at a distance in one of the fetching expressions produced by their lively natures and frank, open and inquisitive stares. The effect is embellished by flowing hair and the freshness of complexion.

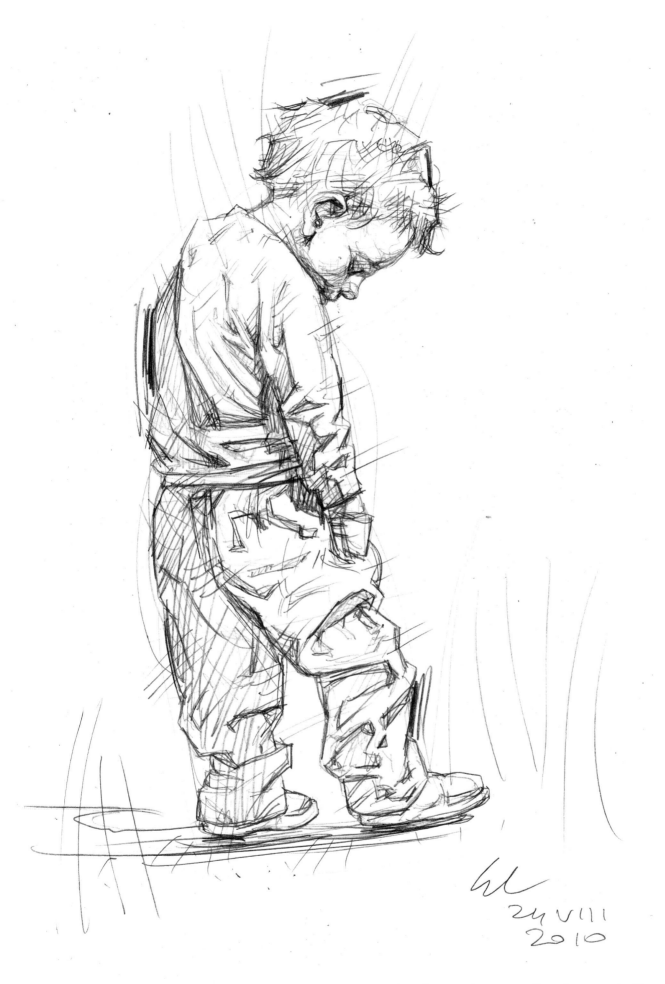

Little Pilgrim to Lourdes (2010), HB pencil on paper, 22.5 × 31.5cm (9 × 12½in)

The face forms only a part, (albeit the most significant part), of our bodily expression; sometimes it is nice to include the entire pose, suggesting it in a few summary lines.

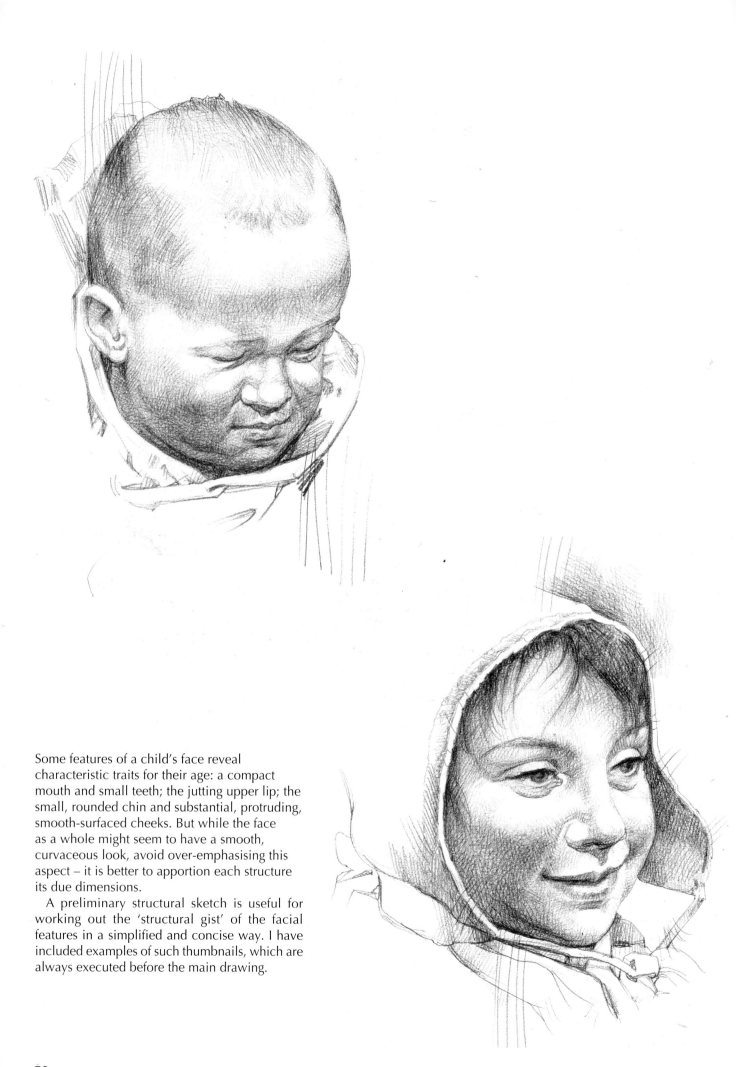

Some features of a child's face reveal characteristic traits for their age: a compact mouth and small teeth; the jutting upper lip; the small, rounded chin and substantial, protruding, smooth-surfaced cheeks. But while the face as a whole might seem to have a smooth, curvaceous look, avoid over-emphasising this aspect – it is better to apportion each structure its due dimensions.

A preliminary structural sketch is useful for working out the 'structural gist' of the facial features in a simplified and concise way. I have included examples of such thumbnails, which are always executed before the main drawing.

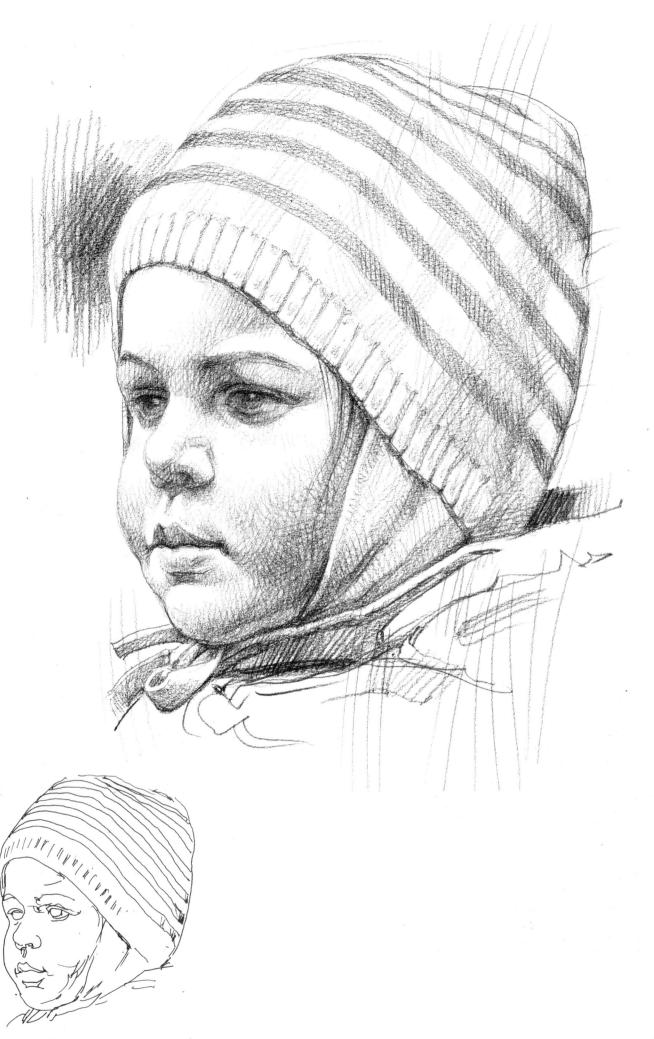

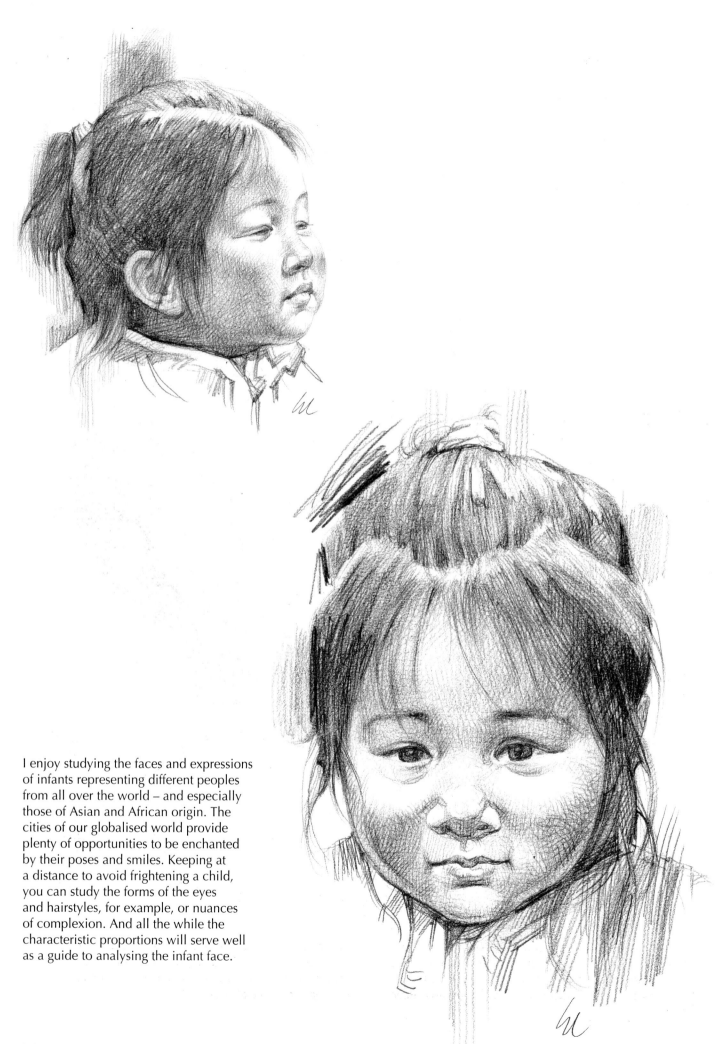

I enjoy studying the faces and expressions of infants representing different peoples from all over the world – and especially those of Asian and African origin. The cities of our globalised world provide plenty of opportunities to be enchanted by their poses and smiles. Keeping at a distance to avoid frightening a child, you can study the forms of the eyes and hairstyles, for example, or nuances of complexion. And all the while the characteristic proportions will serve well as a guide to analysing the infant face.

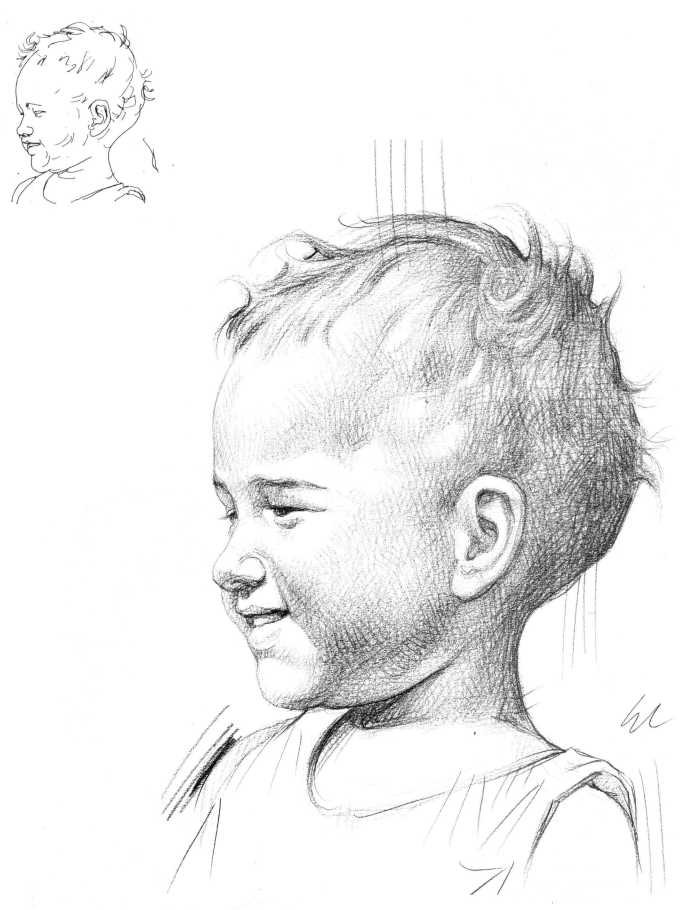

When portraying very young children, (for instance, up to the age of 6 or 7), photographs will be an essential aid because children are always in movement and both their expressions and their moods change with lightning speed. This means that you can, at best, only execute quick sketches. However, photographs should only serve as an instrument for recording visual impressions and capturing fleeting poses (see also page 4).

HEADS AND FACES OF OLDER PEOPLE

The time-worn faces of older people, marked by the ups and downs of life, make a welcome and much appreciated subject for the artist, offering many aspects for study through a variety of lines, mass, light, shade and form. As the face ages, it changes. This is only partly due to the presence of wrinkles, which become progressively more numerous and obvious. There is no need to reproduce every line on the face, or even to highlight any, which can all too easily lead to an involuntary caricature. It will suffice to make a good analysis of the directions taken by the main lines on the skin and the play of light and shade that they produce. Wrinkles may result from pockets of fat forming beneath the skin, as well as from the skin losing its elasticity, but they are also signs of oft-repeated facial gestures – some of them bearing witness to expressions that have characterised the face throughout its lifetime.

Knowledge of anatomy pays its greatest dividends when drawing the face of an older person. One of the signs of age is how the cranial and facial bones tend to rise to the surface, (especially around the cheekbones and the orbits of the eyes), while the facial muscles begin to waste and deposits of fat form pockets around the eyelids and under the chin. Hair turns white and thins; the nose and ears have continued to lengthen gradually over a lifetime and lose their thickness; the folds of the neck become more pronounced; dark patches of various hues appear on the skin, and so forth. Even the face's proportions undergo a degree of change as loss of teeth and the thinning of the jawbone reduce the dimensions of the lower part of the face.

Older people make perfect models. They can be drawn unawares, (while fully maintaining their spontaneity of expression and attitude), or, when asked to sit for a portrait, they will often be less impatient than younger models and will hold a calm, relaxed pose for a long time.

Drawing of the directions of the principal and most common folds and lines of the face: wrinkles are fairly light, fine and shallow furrows, while folds are more substantial and pronounced. These are formed, in particular, on the forehead, around the eyes, at the sides of the nose and of the mouth, under the chin and in front of the ears.

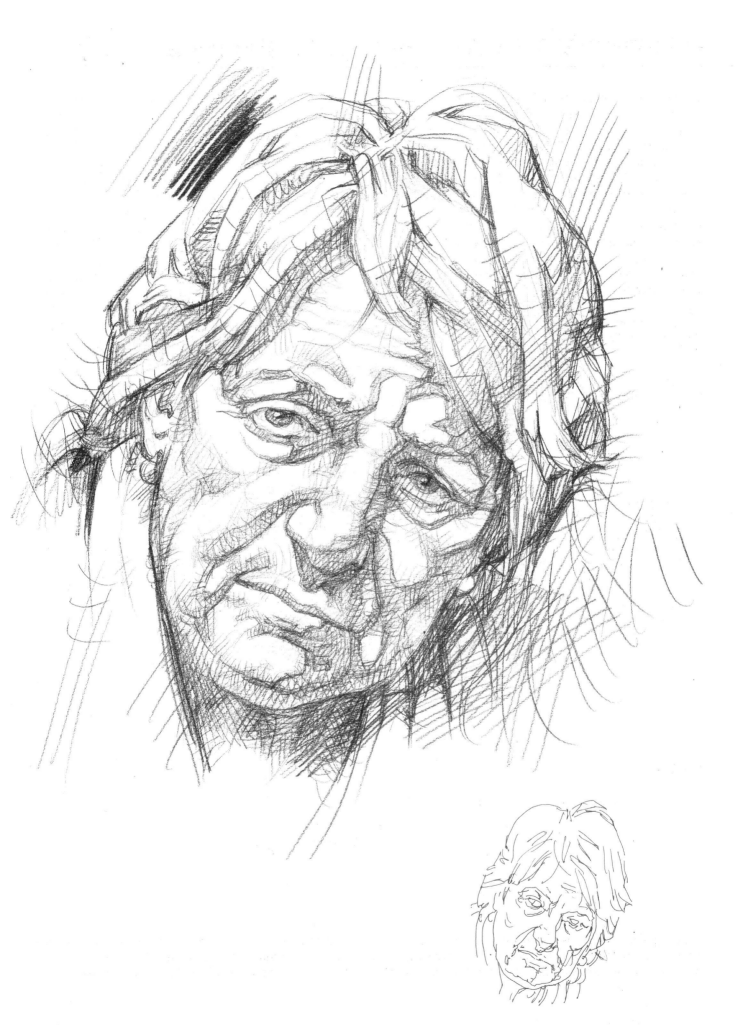

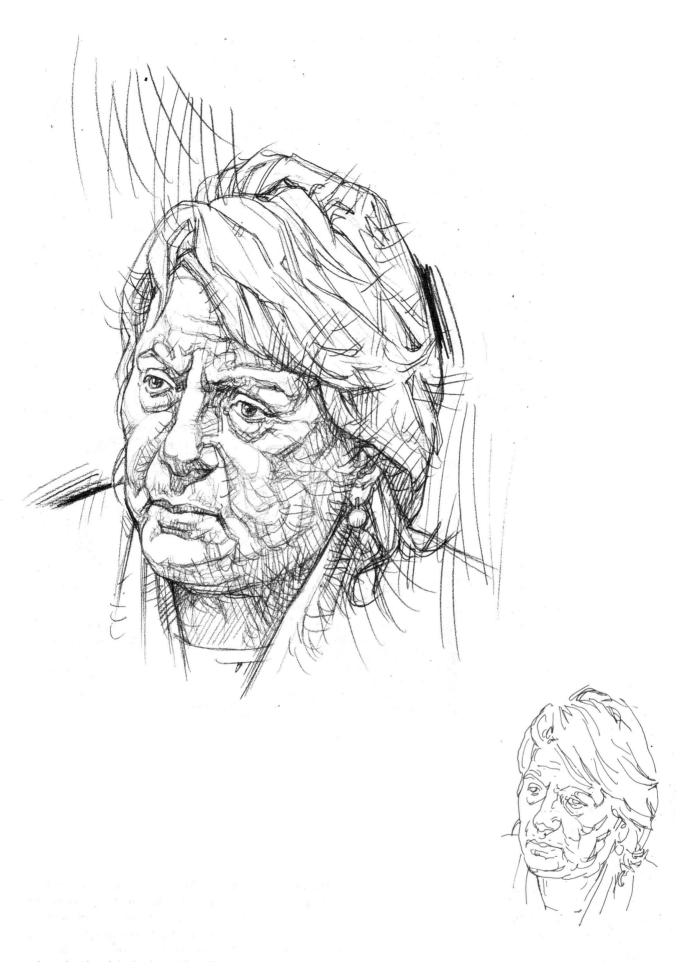

A face that has lived a long life tells us much about its owner, about character and the kind of life that has been lived. Wrinkles, creases and subcutaneous veins are in evidence and their arrangement is an important factor in portraying the model's physiognomy and suggesting personality.

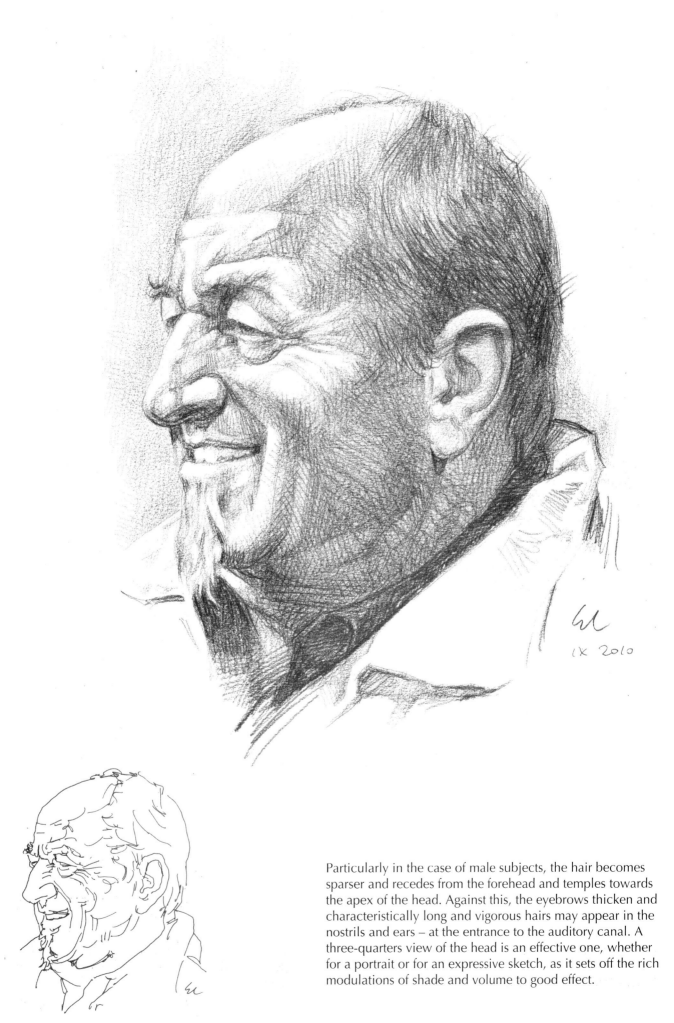

Particularly in the case of male subjects, the hair becomes sparser and recedes from the forehead and temples towards the apex of the head. Against this, the eyebrows thicken and characteristically long and vigorous hairs may appear in the nostrils and ears – at the entrance to the auditory canal. A three-quarters view of the head is an effective one, whether for a portrait or for an expressive sketch, as it sets off the rich modulations of shade and volume to good effect.

59

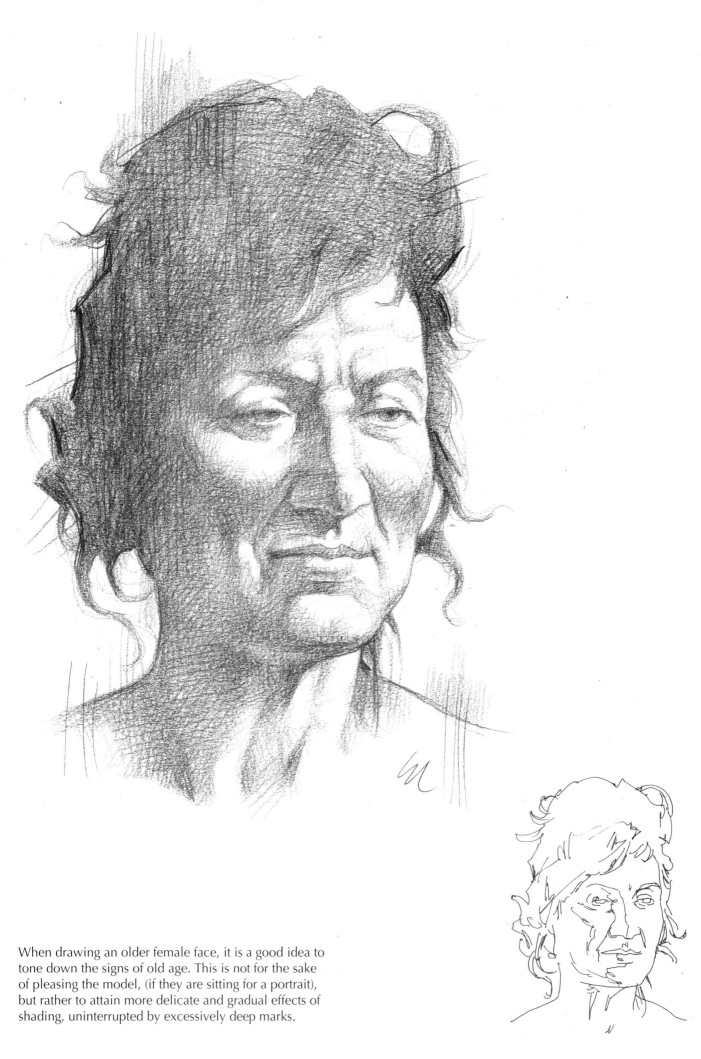

When drawing an older female face, it is a good idea to
tone down the signs of old age. This is not for the sake
of pleasing the model, (if they are sitting for a portrait),
but rather to attain more delicate and gradual effects of
shading, uninterrupted by excessively deep marks.

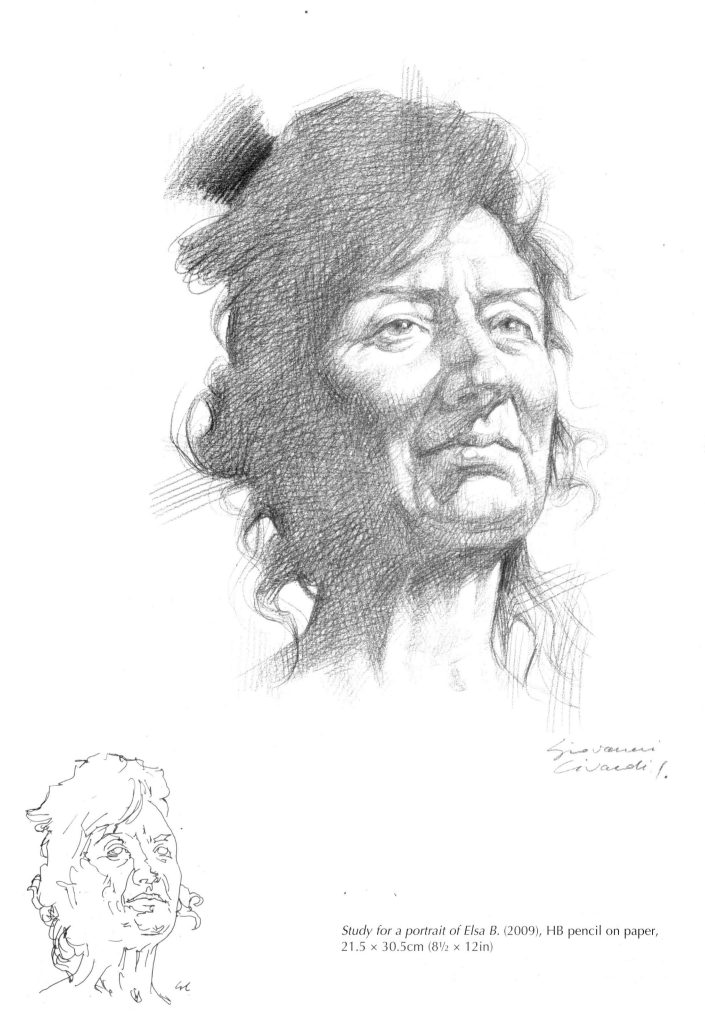

Study for a portrait of Elsa B. (2009), HB pencil on paper,
21.5 × 30.5cm (8½ × 12in)

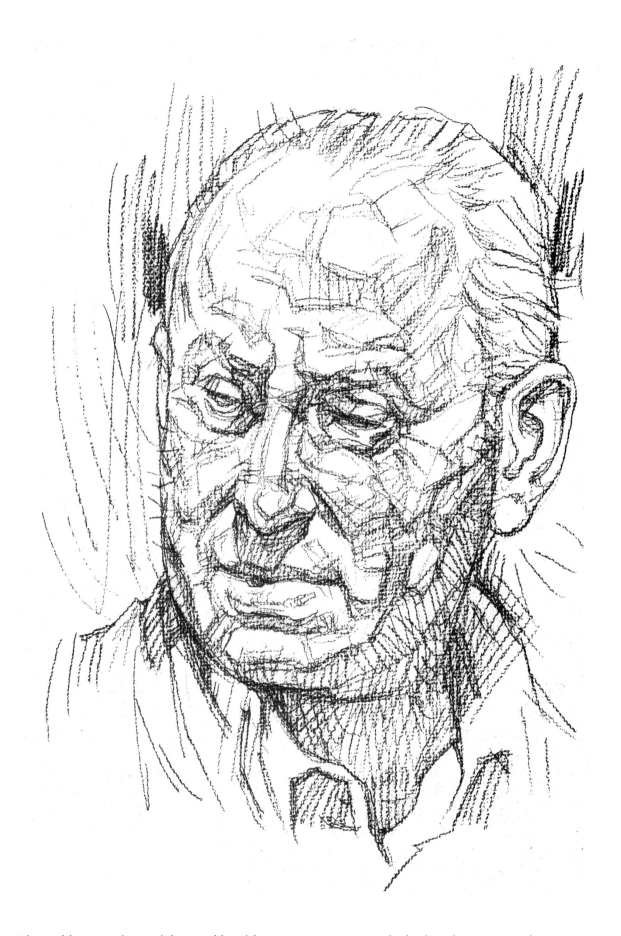

With an older man, the modulation of facial features is much more rich and complex than on a younger individual. This means that the planes into which the surface of the face may be broken down are much more numerous, and this will affect the way light and shade falls on the face.

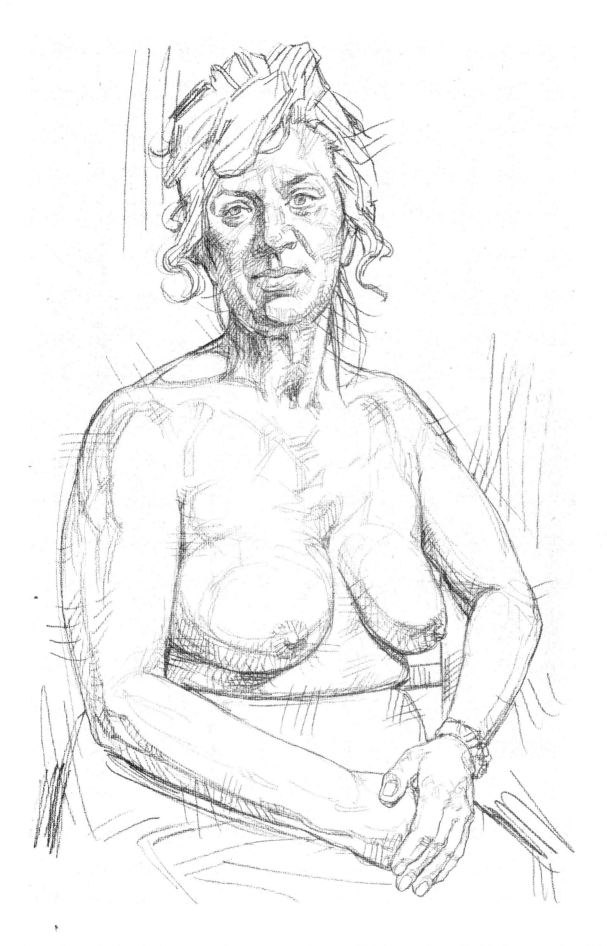

Even at an advanced age, the female figure provides a unique source of interest for a sensitive study of 'mature' forms, which harmonise well with the expression of the face and with the simple serenity of the pose.

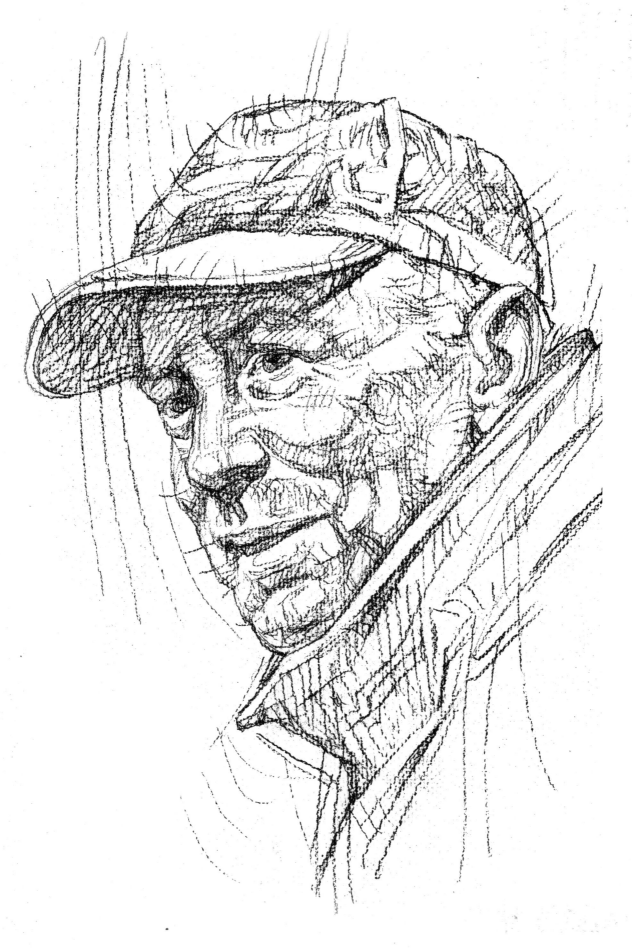